GORD PETERAN

FURNITURE MEETS ITS MAKER

D1596405

GORD PETERAN

FURNITURE MEETS ITS MAKER

Glenn Adamson

with contributions by

Gary Michael Dault

David Dorenbaum

Gord Peteran

Milwaukee Art Museum

Chipstone Foundation

This catalogue was published in conjunction with the exhibition *Gord Peteran: Furniture Meets Its Maker*, organized by the Milwaukee Art Museum and the Chipstone Foundation. The exhibition and the publication were made possible by an Artist Exhibition Series grant from the Windgate Charitable Foundation.

Exhibition Itinerary

Milwaukee Art Museum, Milwaukee, Wisconsin
October 5, 2006–January 7, 2007

Cranbrook Art Museum at Cranbrook Academy of Art, Bloomfield Hills, Michigan
February 3–April 1, 2007

Winterthur Museum, Winterthur, Delaware
May 12–August 12, 2007

Bellevue Arts Museum, Bellevue, Washington
September 13–December 9, 2007

VCUarts Anderson Gallery, Richmond, Virginia
January 18–March 2, 2008

Long Beach Museum of Art, Long Beach, California
April 11–September 7, 2008

Contents

10 Foreword
 DAVID GORDON

12 Letter of Reference for Gord Peteran
 DAVID DORENBAUM

19 Undertaker
 Gord Peteran and the Black Art of Furniture Making
 GLENN ADAMSON

37 The Art of Gord Peteran
 Its Grammars and Distances
 GARY MICHAEL DAULT

51 Objectology
 GORD PETERAN AND DAVID DORENBAUM

69 Works
 GLENN ADAMSON

179 Gord Peteran's Top Ten Shop Rules

180 A Hypothetical Response
 GORD PETERAN

188 Checklist of the Exhibition

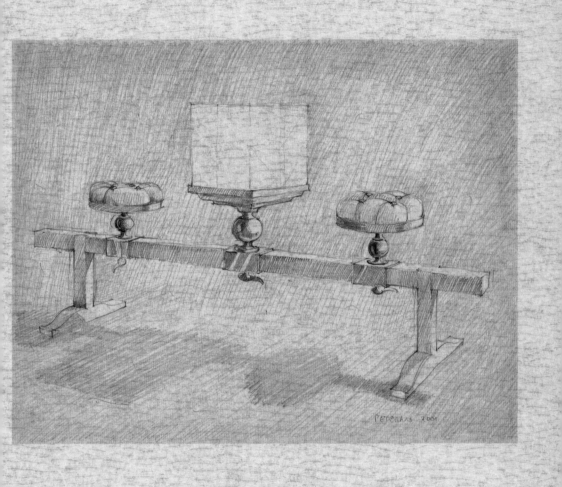

Foreword

David Gordon

Letter of Reference for Gord Peteran

David Dorenbaum

Foreword

DAVID GORDON | DIRECTOR | MILWAUKEE ART MUSEUM

t is with great enthusiasm that the Milwaukee Art Museum pre-
sents the work of Gord Peteran, an artist who lives in Toronto but
who fits this institution like a long-lost friend. Milwaukee has long
been fortunate to have a vibrant community of collectors and
scholars of antique American furniture, with the result that the
museum's presentation of that material is among the country's very best. Peteran's
engagement with furniture is a witty and elegant counterpoint to this rich collection.

While historical furniture is of interest to the Museum, contemporary art also
forms a major component of the institution's programming. This combination is espe-
cially potent when employed by an artist like Peteran, who draws liberally on ideas
and forms from the past as a way of engaging with the issues of contemporary art.
Without a similar blending of traditional skills, competing new technologies, cutting-
edge design, and conceptual ambition, it would never have been possible to build
Santiago Calatrava's brilliant design for the Milwaukee Art Museum addition, the
Quadracci Pavilion. Completed in 2001, this is truly a handmade building, and few
other communities in America could have produced it so well. Peteran's inquiries into
the nature of art and workmanship thus have a perfect setting here in Milwaukee.

The Chipstone Foundation, which possesses an extraordinary collection in its
own right, takes an active role in planning the Museum's exhibitions devoted to the
decorative arts. On behalf of the institution I thank the foundation for leading the cura-
torial effort of staging the show. Glenn Adamson, formerly at Chipstone and now at the
Victoria and Albert Museum, proposed the project and has carried out his curatorial
and authorial roles from his new home in London. Special recognition should also go
to Jonathan Prown, executive director at Chipstone, for his support of the project, and
to Sarah Fayen, assistant curator at Chipstone and project curator for the exhibition
and this catalogue.

In addition to the local support this project has received, it has also been the ben-
eficiary of an Artist Exhibition Series grant from the Windgate Charitable Foundation of
Arkansas. The grant focuses on midcareer artists who are producing "the most inno-
vative, interesting and expressive work in the contemporary crafts." Peteran fits this

description perfectly, of course. Yet from any perspective the generosity of Windgate in funding not only this book and the presentation of the exhibition in Milwaukee but also the subsequent tour of the project must be considered extraordinary. On behalf of the Milwaukee Art Museum and the venues that will act as hosts for the exhibition on its travels, I can only express my deepest thanks. Additional support has come from the Collectors of Wood Art, which has generously funded a residency for Peteran at the Art Department at the nearby University of Wisconsin, Madison.

Gord Peteran would like to express his gratitude to the Chalmers Awards for Creation and Excellence in the Arts, which are administered through the Ontario Arts Council. In 2001 Peteran was given a Chalmers Award, and in 2004 he received a Chalmers Arts Fellowship, which has made possible some of his recent works. And, finally, the artist and the Museum both extend sincere appreciation to personal supporters and participants in this exhibition and catalogue: Elaine Brodie, whose photographs so well capture the beauty and charisma of Peteran's art; Dan Saal, the Museum's graphic designer, for his exemplary work on this publication; Michael Mikulay, for his creative and fitting exhibition design; Dawnmarie Frank, the Museum's indefatigable registrar; Gary Michael Dault and Dr. David Dorenbaum, both contributors to this catalogue; Karen Jacobson, publication editor; and all the lenders to the show. Special thanks go to William Anderson, the most significant and dedicated collector of Peteran's work. Mr. Anderson has shared his living space with these artworks for years; now he has generously agreed to part with them for a time so that this exhibition can become a reality.

Letter of Reference for Gord Peteran

DAVID DORENBAUM

or matters concerning objects, I recommend to you Gord Peteran. Consult Gord for the object of your desire. At first glance the treatment he will give to your request may appear rather unusual. If you are interested in a chair, I recommend Gord Peteran. He could also make you a bracelet or a door, or a demilune, or paint a landscape and frame it. Never mind the painting, you can just have the frame. For furniture that turns into luggage, I recommend Gord Peteran.

For the object that doesn't give itself away, I recommend Gord Peteran. You will notice how he distresses the object to the point that it speaks. Master of interrogation of furniture, he can make a table confess its secrets. But be careful, what the object may say could take you by surprise! Picture the stinging bowl full of candy in his studio, or the box that you enter and see yourself reflected in the glass as you would see yourself from within your coffin. Caution! Once you are in with Gord, there is no way out. Gord Peteran will wave from the other side quite pleased to see you there as part of the object.

I am a collector and I didn't know it! I owe my awareness of this to Gord. I must confess that when I first heard him introduce me as a collector to William Anderson, another collector of his work, I vehemently resisted. Me? Collector? William, of course, is a collector. His living space is populated by objects made by Gord. Even his body on a given day displays some objects made by Gord: an iron ring, a leather neckpiece, or a bracelet made of the shred of a sharpened pencil. But for me to admit that I was a collector was something else. What do I collect? Why do I collect? These were questions triggered in me by Gord from the moment I first contacted him, years ago, with the request that he design a bookcase for my office.

My objects are remarkable only for the diversity and the contradiction that mingle among them, I thought. My collection of objects must have revealed to Gord something about me that I wasn't aware of. This was potentially dangerous. It could have become a battlefield that turned Gord into the uncontested dominator. However, it did not.

Working arm in arm with him through the commission of an object, following him in his expressive needs, I could understand his natural vocation and the love and pleasure that bind him to his technique. Everything is carefully weighed, even the contradictions. What you can do doesn't interest him. It is what you can't do that becomes interesting. And that is why I recommend you to Gord Peteran. He has the skills and the tools to extract from you the object that may be trapped in your imagination. The object that stands for all the other objects you possess, real or imaginary, the damaged objects, sacred or profane.

This is what he does to his clients: he scares them, he rattles their sense of balance. Master of interrogation, he can make you confess your secrets. But you will forgive him because, upon completion, I guarantee that you will have the thing you asked for, often disguised as furniture. And as the object finally lands in your space, don't be deceived by the strange feeling of recognition and misrecognition that you may experience. On the one hand, it will seem to you something totally unexpected, a surprise. On the other, you will feel a strange sense of familiarity.

Time is of critical importance in the process. Witness how the object, like any other event, happens in time. Gord trusts nothing! I view this as one of his strengths. With surprise you may notice that, in spite of his years of experience, each time, for each object, Gord creates afresh the terms, the techniques, and the tools. This holds true for every step. As you may imagine, it takes time.

I have known Gord for a long time. However, the observations I convey to you in this letter are based on my impressions of having been his client only once. He has made one object that presently stands in my office. Between the couch and my chair stands this third object, the object that gives to books their place. Books mean a lot to me. So why is it that after all these years of having had the bookcase in my office, and having called it the perfect bookcase, there is not a single book in it?

Gord must have understood that I was asking him for something else. He must have known that this bookcase was meant to contain all the impossibility that exists in every object, including books, but not only books, objects that stand for something lacking in me. I have transferred that void onto the books, books I have read, books I have not read, the book I wish I had written, and even onto every object I possess. That is what gives them their mark of uniqueness. They all share that empty space. Yes, during a regular working day at the office, I am in the company of all these books. Thanks to the bookcase, each of them has found a place. For the perfect bookcase, I recommend Gord Peteran.

Dr. David Dorenbaum is a psychoanalyst in private practice in Toronto. He is a member of the International Psychoanalytic Association and an assistant professor in the Department of Psychiatry in the School of Medicine at the University of Toronto.

Undertaker
Gord Peteran and the Black Art of Furniture Making

GLENN ADAMSON

T he found object is a good place to start with Gord Peteran. That, after all, is where he often starts. A rickety ladder-back chair from a dumpster, a pile of scrap wood, a pencil, a heap of twigs: these are some of his raw materials. Peteran will take one of these things and operate on it in some way, creating a work while leaving the thing itself more or less intact. The strategy does not have to be literal, though; it is best taken as an analogy for his practice in general. He has taken the category of furniture, or more precisely, that which he calls the "furnitural," as a found object in its own right—a thing to be operated upon conceptually while at the same time left in place. At Peteran's hands furniture dies a fascinating death, without ever quite going away.

At the level of content, Peteran's ideas about furniture are hardly unusual. He is interested in the same things that fascinate most people who think about it—the ways that it supports, surrounds, and symbolizes us in the course of our daily lives. These matters of use, environment, and style are the primary concerns of "studio furniture," a field of activity that has become increasingly well defined over the past two decades. Studio furniture makers are undoubtedly Peteran's closest colleagues, yet it is not at all clear that he should be counted among them. It is an accepted axiom that studio furniture makers are engaged in an examination of their medium's social and formal properties, which is a fair though incomplete description of what Peteran does. It would be more accurate to say, however, that studio furniture makers do not examine their medium's properties so much as exploit its possibilities. The common goal of "expression" holds across a wildly diverse field: it is the single element that unites classically minded studio furniture makers, who perceive themselves to be artisans; sculptors, who use furniture as a premise, or excuse, to invent new forms; and post-modernists, whose objects are a pastiche of quoted sources. Makers working in all three of these modes, as vital as their furniture may be, and as incisive as it may be in holding up a mirror to culture, are not in the end interested in an examination of furniture per se. Their work is open-ended and creative. Put simply, studio furniture makers have a tendency to take furniture for granted. They tend to begin with the idea

of a cabinet, a chair, or a table and go from there. They end up, inevitably, with a piece of furniture that has "artistic" qualities.

Peteran is not expressive in this way. One of his most telling characteristics as an artist, in fact, is that he limits his own options at every step. For this reason he thrives on the commission process, in which his artistic goals are artificially bounded from the outset. This aspect of his work marks him, like most great artists of his generation, as a child of Conceptualism. Each of his pieces appears superficially to be an example of a genre (chair, table, drawing) but on closer inspection proves to be a tautly devised proposition about the nature of that genre. What would perhaps feel suffocating or trivial to another maker, such as the task of designing a trophy for an organization's award ceremony, is

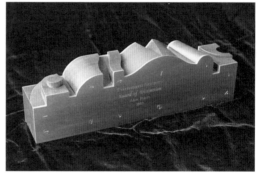

FIG. 1

Gord Peteran

Furniture Society Award

for Peteran a welcome opportunity to restrict his possibilities (fig. 1). Even when he is working speculatively, without a brief from a client, he invents insurmountable obstacles for himself. He may or may not get to the point of making a chair or a table at all, even when it is quite clear that such was his intended original destination. The single corner joint entitled *A Little Table* (2002; cat. 13) is the clearest illustration of this stopping short, but it is a theme that runs through all his best work. One of the hortatory "shop rules" posted on the wall of Peteran's studio reads, "If you don't do something, you probably won't." There is everywhere in his work an incompleteness, a resistance to fully occupying the normal relations between form and function.

This incompleteness is not to be mistaken for the liberation of form from function that is commonly celebrated as an achievement of the creative sculptural crafts. It is rather a deliberate failure to allow either form or function, considered more or less independently, to come to fruition. Once this principle is grasped, works of Peteran's that initially seem merely poetic and elusive become almost diagrammatic. In *A Table*

Made of Wood (1999; cat. 8), form is caught precisely at the moment of its own becoming. *An Early Table* (2004; cat. 18) and *An Early Knife* (2004; fig. 9; p. 43) imply a fictional anthropological narrative, similarly arrested. In *Three Bronze Forms* (2002; cat. 15) we are given enough information to see that a game is afoot—but what is the game to be played? Even *Ark* (2001; cat. 9), an unusually monumental and formally resolved work by Peteran's standards, nonetheless frustrates our minimum expectations of an object. It is composed of panels that tip out of their proper planes, as if they were trying to sneak away from the scene of the crime, and its intended function is not so much multivalent, as one might expect in such a complex work, but ambivalent—so unstated as to be subliminal.

What underpins Peteran's attitude to form is not expression, then, but the now venerable logic of the found object. Since the readymades of Marcel Duchamp, artists have been finding new and clever ways to make objects that are not fully themselves. So, just as Duchamp's *Fountain* (1917) doesn't quite arrive at being a urinal, Jasper Johns's paintings and sculptures aren't quite targets and beer cans, and Damien Hirst's *Physical Impossibility of Death in the Mind of Someone Living* (1991) isn't quite a shark in an aquarium. The conceptual space between an everyday object and a readymade, while it can be achieved in a bewildering variety of ways, is at root quite simple. The readymade possesses the smallest possible difference between a thing we know and a thing we have never experienced before. To make a successful work from a found object requires not wild creativity, but extreme restraint. It demands a winnowing process in which the artistic gesture is isolated as a single point of radical transformation. Just as a knife cuts because of the thinness of its edge, a readymade's power derives from this narrowness.

Peteran and his psychoanalyst, David Dorenbaum, occasionally teach a class together at the Ontario College of Art and Design, entitled Advanced Visual Language. One of the course assignments is called "Maximum Shift/Minimum Intervention." In this exercise the students are asked to take an everyday object and perform one and only one operation on it. The goal, Peteran says, "is simply to strengthen the students' efficiency." Among his favorite outcomes, in his own words: "A girl purchased one of

those metal PUSH signs and stuck it to
the inside of the classroom door. . . . The
door opens in. We all shared a sense of
panic." A survey of Peteran's oeuvre
unearths many ingenious applications of
"Maximum Shift/Minimum Intervention":
Workbench (Compass) (2002; cat. 16);
Mechanics of Memory (2002; cat. 14); and
his interventions into the wood-turning
world, particularly *Untitled So Far* (1996;
cat. 6) and *Five Sounds* (2002; cat. 12),

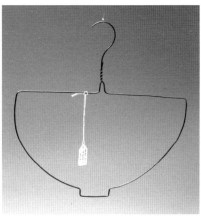

FIG. 2

Gord Peteran

*Hanging
Salad Bowl*

2004

are all examples. It is notable that turning, that most enthusiastic and earnest subdivision of the North American studio craft world, is a climate that Peteran finds especially stimulating to his use of the found object (fig. 2). A very limited field of enterprise like turning is useful to him because its parameters provide conceptual friction.

It is for the same reason that found
objects are necessary for Peteran. They
help him create a space between the condition of furniture and the much less certain, less complete condition that his own
works occupy. In this respect he reminds
me of the late Robert Arneson, who was a
ceramist rather than a furniture maker but

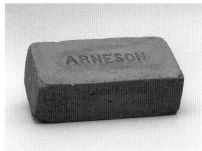

FIG. 3

Robert
Arneson

Arneson Brick

1975

was involved in a similar struggle-to-the-death with his own craft. In the 1960s, without actually resorting to found objects, Arneson nonetheless indicated strong affinities with the traditional use of the readymade as a tool of merciless self-investigation. He made handmade toilets, recalling Duchamp's *Fountain*, but he also fabricated other quotidian ceramics such as bricks and flowerpots (fig. 3). Arneson was proceeding from the assumption that, as a potter, he had to take the medium of clay as it came, its embarrassing baggage along with its glorious history, its marginalia as well

as its monuments. Peteran's furniture is equally confessional in its overtones, but it is also more purely conceptual and less psychological than Arneson's so-called Funk. The emotional suggestiveness of Arneson's sloppy clay is replaced with the precise surgery of honed wood and metal. What the two artists have in common is not affect but attitude. Peteran shares Arneson's smiling yet unflinching sense that at any moment he might just give up on the crafts, those poor relations of the fine arts. Of course Arneson never did, and one suspects that Peteran never will either. For both artists, a bit of self-loathing is the fuel for the fire. Peteran sums it up in his shop rules: "If something's not worth doing, it's worth not doing well; if something's worth not doing well, it might be worth doing perfectly."

hen assessing the development of Peteran's work over the past twenty years, the key question is that of style—in the sense that as he has matured as a maker, a distinctive personal style has played less and less of a role. At the beginning of his career he made two pieces that presage his later conceptual work but that are stylistically unrecognizable as his own: *Chair with Arms* (c. 1977; cat. 1) and *Chest on Chest* (1984; cat. 2). Then Peteran entered into what might be called a romantic phase. His next pieces were heavy with symbolism and show that he was trying, perhaps too hard, to put his considerable artisanal and compositional talents on display. His door for the Ontario Crafts Council (1990; cat. 3) epitomizes this stage in his career: a veritable explosion of iconography and fine workmanship. This was studio furniture, and quite good studio furniture at that, beautifully designed and made, even if it exhibited somewhat gothic stylization and self-indulgent impulses. In fact, these romantic works have staying power mainly because of, and not despite, their sinister quality. What seems at first to be only an impressively constructed clock or music box does double duty as a machine of unclear but definitely ominous purpose. Peteran is a man who enjoys being psychoanalyzed, and it might be that in early works he was sublimating his own dark sentiments about his calling.

In any case, the shedding of style in favor of the logic of the found object has been the key dynamic in his progress as a maker. The paired metal tables and carrying case that Peteran collectively entitled *100* (1996; cat. 5)—the single piece that most clearly marks the conceptual turn in his career—illustrates the point. A lethal aura is carried over from his earlier work, but that quality is no longer expressed in stylistic terms. Rather it is lodged at the center of the artistic conception, which in this case is a not-quite-explicit analogy between a rifle and a table. The feeling of dread is dispersed through *100*, not sitting on its surface like ornament. The same can be said for subsequent works like *Ark* and *Maypole* (2003; cat. 17), which are both complex constructions but carried off without any obvious stylistic mannerism.

It would be wrong to say that style plays no role in Peteran's art. In future years his favored materials (dark wood, brushed metal, red velvet) and his svelte, taut forms

may seem as characteristic of the present decade as bellbottoms now seem of the 1970s. It is probably true, that is to say, that all his work can be seen through the lens of style to some extent, and indeed that style is unavoidable in any art that refers explicitly to furniture. Again, though, it is important to see Peteran's current usage of style as a departure from that usually observed in studio furniture. A contrast can be drawn between his work—say, *Prosthetic* (2001; cat. 10)—and studio furniture maker Tom Loeser's series

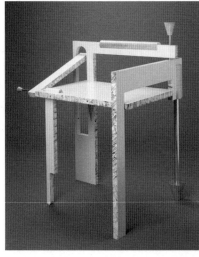

FIG. 4

Tom Loeser

Folding Chair

1982

of *Folding Chairs*, made during the 1980s (fig. 4). Loeser's ingeniously constructed seating forms can be folded flat and hung on the wall like paintings; they are cheeky, semiotically charged riffs on the self-conscious postmodern design that was so much in the air at the time. Like *Prosthetic*, they go right to the heart of the idea of a chair and its location within a larger world of forms and ideas. But style is painted, literally, all over Loeser's *Folding Chairs*: he made many of them and varied them through the application of various eye-catching color palettes and patterns. Peteran would never do this. For the most part he makes only one version of an object and makes it as neutrally as possible. When he does make multiples, as he did with *A Table Made of Wood*, the variations seem pointedly accidental, governed by the happenstance of material and making, rather than by any positive act of selection.

Further insight into this policy of aesthetic neutrality might be gained through a second comparison: Garry Knox Bennett's *Nail Cabinet* of 1979, a handcrafted display cabinet with a nail driven unceremoniously into its front, which is today perhaps the most famous single piece of studio furniture. When asked to explain this absurdist act, Bennett said only that he thought "people were getting a little too goddamn precious with their technique," a sentiment that Peteran would endorse to an extent—he has

said that "techniques rarely improve the impact of objects." Unlike Peteran's own investigative proddings of the field of wood turning, however, which are marked by curiosity rather than antipathy, Bennett's gesture took aim squarely at the culture of a studio craft field. His gesture was shocking primarily because of its aggressiveness, not its conceptual complexity. For the conceptual action of *Nail Cabinet* to take effect, the piece had to be finely made and beautifully styled, but this workmanship was justified only by its subsequent negation. The suggestion was that studio furniture mak-

ing trades in the arbitrary—that its techniques were overvalued and the styles achieved through such expertise largely irrelevant. Ironically, in the decades since, Bennett has been perhaps the most adroit manager of a distinctive "signature style" in American studio furniture, pumping out a vast array of impressive objects featuring cartoon forms, overarticulated joints, and symbolic motifs (the checkerboard, the squiggle). Thus, although he is probably the most successful avant-gardist of his generation, his work is nearly the opposite of Peteran's. Occasionally Bennett tips his hand, though, revealing a purely conceptualist strain in his sensibili-

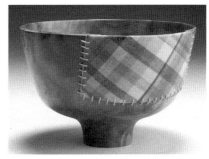
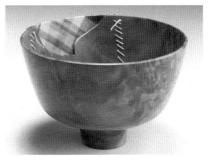

FIG. 5

Garry Knox Bennett

Patch

2005

ties. Unsurprisingly a found object is frequently the vehicle. A good recent example is a lovely Bob Stocksdale turned bowl with a crack in it, which Bennett "repaired" using a swatch of plaid fabric (fig. 5). This piece has some of the satire of *Nail Cabinet*, but it also bears the marks of strong personal affection. Another example: when Peteran made his seminal work *100*, it found only one buyer, and that was Bennett himself.

P eteran also draws. When asked about this aspect of his practice—asked, in fact, to suggest a few drawings that might be included in the present book—he responded with his characteristic blend of hauteur, elusiveness, and wordplay: "My whole life is nothing but drawing. I have a billion drawings. That's what I do. So for you to throw out the word *drawing*, you don't even know what that doesn't mean to me." Peteran claims drawing as the everything-and-nothing at the center of his artistic activities. For the most part, his drawings seem to be dissociated from the rest of his work. He does make study drawings occasionally, but they are a tiny fraction of his graphic output; most of his subjects are towns and landscapes, people, still-life arrangements—the standard repertory we would expect from a student of the medium. These renderings are usually made in a way that pointedly announces their unimportance, often drawn on scraps of paper or even coffee filters.

On the one hand, then, drawing is for Peteran a work forever in progress but going nowhere special. On the other hand, as he is fond of saying, "wood is just thick paper." The process of making furniture is only the most concrete and conspicuous of his acts of ideation, the top of an edifice of which incessant drawing is the foundation. So much is demonstrated by *Electric Chair* (fig. 6), a recent work that consists entirely of the tubular steel frame of a found Marcel Breuer–style chair, a cord, and a light bulb (again, shades of Garry Knox Bennett, who frequently fashions lamps from odds and ends found in and around his studio). This seems at first to be nothing more than a mild joke, and the piece is certainly slighter and funnier than most of Peteran's output. It does, though, exemplify his interest in pursuing ends through

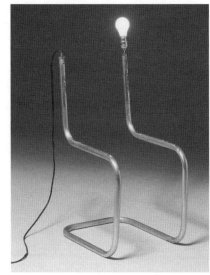

FIG. 6

Gord Peteran

Electric Chair

2004

the most minimal of means. Query the artist about it, and he'll tell you that his main interest is in emphasizing the fact that the frame itself is "a drawing in space." This observation is not exactly breaking news—it's common knowledge that the modernists' tubular steel chairs were an outgrowth of the Constructivist exploration of form—but it's one thing to make the observation, another entirely to actually turn a chair into a line. Occasionally Peteran makes a piece like *100*, which is obviously the product of mechanical drawing. He is willing and able to use drawing as a planning tool, as an industrial designer would. And, in fact, one of the careers that Peteran has flirted with is contract design. In the early 1990s he participated in the design of a series of five chairs for the Canadian manufacturer Keilhauer, all of which are still in production. Today he regards these as relatively conservative, and despite the fact that the experience was a positive one for him, he has not returned to the field since. Thus draftsmanship—in the sense of both design for mass production and drawing for its own sake—informs all his work, but only in a sublimated fashion.

Furniture restoration functions similarly for Peteran. As he puts it: "Knowing now that all things are connected—in all directions, all at once, and that nothing much 'begins'—I began restoring furniture at birth. It turned into the repair of wooden objects professionally when I was fifteen." Working first for an uncle in the antiques business and then for that uncle's neighbor (a "marvelously critical retired designer/builder millionaire"), Peteran acquired the basic skills of the trade as a teenager. He learned what it is to be a restorer: a craftsman who takes for granted the fact that all furniture is destined for the scrap heap, that to work on a piece of furniture is to save it temporarily by irretrievably altering it, and that a job never starts from scratch, but is a reaction to an existing state of affairs. For years Peteran has put these precepts into practice by annually restoring a battered old chair. *Prosthetic* is one result, but not the only one. As the dual narrative by David Dorenbaum and the artist included in this volume ("Objectology") attests, Peteran's acts of restoration can extend to the point where they encompass the possibility of destruction. This theme appears periodically in his work: the idea that making furniture can be a subtractive rather than an additive art. The startling gesture of burning a good friend's cherished

chair implicitly suggested that a phoenix of some sort might rise from the ashes. But to accomplish this, the gears needed to be thrown into reverse: "We needed to back up," the artist writes, "before the chair's arrival, to the anti-object, to the pre-object." The only resolution one can ever expect from Peteran, then, must pass first through a destructive act—his word is *exorcism*—which keeps easy satisfaction in abeyance.

Peteran's fundamentally resistant nature raises, inevitably, the question of his true ambition. So far his relation to other artists has been that of a provoca-teur, not a leader. Whether he even belongs to a "field" (in the sense of a com-munity of like-minded souls) is doubtful. There are certainly other artists who use furniture forms in their work and who freight those forms with psychological weight, such as Mona Hatoum and Doris Salcedo (figs. 7 and 8). But these artists deploy furniture from an exterior position, exploiting its generic qualities to operate on some other concern, such as autobiog-raphy, gender construction, or received cultures of domesticity. Peteran, by con-trast, has taken up a position within furni-ture, if only in order to better destroy it. In this stance lies his real singularity, yet he claims that his maneuver is an obvious one: "The area between the intimate objects of the home and the psyche is exactly where any great sculptor would want their work performing. This is what

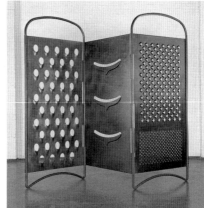

FIG. 7

Mona Hatoum

Grater Divide

2002

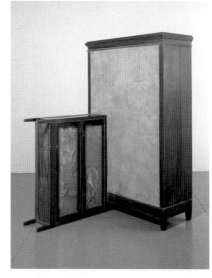

FIG. 8

Doris Salcedo

Untitled

2001

sculpture claims it wants, but has never had the wherewithal to do. I don't see my work as sculptural furniture; I see it as the only place to point my arrow. I have no interest in furniture. It just seems to be already milling around in the only territory worth targeting . . . or very close to that territory."

Call him what you will: a fly in the ointment, an upsetter of the apple cart, or just a wise guy, but in the end, Peteran's work is the acid test for those who operate in the terrain of the "furnitural." In fact, he may already have killed off what they thought was worth saving. And, as he is fond of saying, "I'm just getting started." What happens in the future will reveal, in retrospect, the true character of Peteran's position in art history. As for the final aims of his undertaking, they can best be summed up in his own elusive words (for, as a final Peteran shop rule has it, "What people say is quite often a clue to what they're thinking"). When I told Peteran the title of this essay, he responded approvingly: "That's what I do, I guess. Primp it, box it, and bury it. By the end of my career I will have made everything invisible. Or at least harder to see."

Glenn Adamson is head of graduate studies and deputy head of research at the Victoria and Albert Museum. He was previously curator at the Chipstone Foundation.

NOTE
All quotations from the artist are from conversations and correspondence with the author that took place between around 2000 and 2006.

FIGURES

FIG. 1
Gord Peteran (Canadian, b. 1956)
Furniture Society Award
Mahogany and copper

FIG. 2
Gord Peteran (Canadian, b. 1956)
Hanging Salad Bowl, 2004
Found and altered wire clothes hanger, paper tag
12 1/2 x 12 1/2 x 1/4 in. (31.8 x 31.8 x .6 cm)
Collection of Albert and Tina LeCoff

FIG. 3
Robert Arneson (American, 1930–1992)
Arneson Brick, 1975
Earthenware
8 1/2 x 4 1/4 x 2 5/8 in. (21.6 x 10.8 x 6.7 cm)
The David and Alfred Smart Museum of Art, The University of Chicago; Gift of Allan Frumkin.

FIG. 4
Tom Loeser (American, b. 1956)
Folding Chair, 1982
Painted wood, metal
33 1/4 x 27 3/4 x 21 1/2 (84.5 x 70.5 x 54.6 cm)
Brooklyn Museum of Art; Gift of Mark Isaacson and Charles Stewart Smith Memorial Fund
1991.92a–b

FIG. 5
Garry Knox Bennett (American, b. 1934)
Patch, 2005
4 x 6 in. diam. (5.1 x 15.2 cm)
Collection of Sylvia and Garry Knox Bennett

FIG. 6
Gord Peteran (Canadian, b. 1956)
Electric Chair, 2004
Tubular steel, light bulb
30 x 14 x 16 in. (76.2 x 45.6 x 40.1 cm)
Collection of David Dorenbaum

FIG. 7
Mona Hatoum (Palestinian, b. 1952)
Grater Divide, 2002
Mild steel; edition of 3
80 1/4 x 1 3/8 in. (203.8 x 3.5 cm)
(width variable)
Courtesy of Alexander & Bonin, New York

FIG. 8
Doris Salcedo (Colombian, b. 1958)
Untitled, 2001
Wood, concrete, glass, fabric, steel
80 x 67 x 50 in. (203.2 x 170.2 x 127 cm)
Courtesy of Alexander & Bonin, New York

I ALWAYS DRAW AROUND THIS TIME OF YEAR.
IT BRINGS BACK THE DEAD.

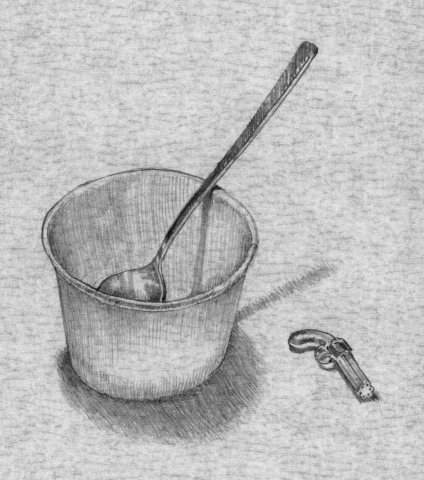

EMPTY FRUIT CUP AND A SMALL REVOLVER

PETERAN DEC 2000

The Art of Gord Peteran

Its Grammars and Distances

Gary Michael Dault

Conjunction

ord Peteran's witty, wicked, often downright pixilated acts of furni-
ture making have always felt linguistic to me: clausal, preposi-
tional, conjunctive.

Clausal, in the sense that one active-making, verblike thrust of
idea informing a piece (say, the idea that the table of *A Table Made
of Wood* [1999; cat. 8] is composed of randomly harvested bits of wood—table scraps,
as it were) invariably leads to another (say, to the idea that the heterodox bits of wood
in *A Table Made of Wood* do indeed coalesce somehow into fully realized table-ness).[1]

At the same time, the works are prepositional (pre-positional). Each of them
offers an early, imagistic point of entry, a key to the door. The idea, for example, that
there certainly is a lot of stuff hanging on the coatrack of *Mechanics of Memory* (2002;
cat. 14) serves, prepositionally, as a point of entry to the meaning that will be devel-
oped more fully in the revelations offered by the work's eventual coming to us whole:
that a single armature certainly can support and unify a lot of disparateness, for exam-
ple, the way a spine holds aloft a head teeming, jangling with impulses and ideas,
or that "we are a part of all that we have known," and so on and so on.

Finally, the works are conjunctive. Peteran appears to build into them the insis-
tence that we apply to each piece E. M. Forster's stunningly simple admonition: *only
connect.*[2] The works are conjunctive, in other words, in their seeming conviction that
"both/and" is a more productive watch cry in the workshop than "either/or." *Ark*
(2001; cat. 9), for example, is both cage and conveyance, both vitrine and vehicle.
Maypole (2003; cat. 17) is both solidly planted on four legs and, at the same time,
powered by an energizing instability, with much potential dangling and swinging. *100*
(1996; cat. 5) is both the carrier and the carried, nutshell and nut, womb and fetus,
chicken and egg, the maker and the made (for, after all, the table seems not just
elegantly housed in its case but constantly reborn from it). Figure and ground: but
which is figure and which is ground?

So I like the fact that you can parse Peteran's pieces—that a procedural grammar
everywhere informs them.

A number of the virtuoso manifestations of the artist's conjunctivity—which is sometimes detected, in his work, as the brimstone-whiff of surrealism (one recalls the Comte de Lautréamont's famous remark that convulsive beauty lay "in the chance meeting on a dissecting table of a sewing-machine and an umbrella")—lie in his bringing together and reconciling what are presumably irreconcilable modes: the homely wood and rushes of the cast-off "Shaker (style) chair" of *Prosthetic* (2001; cat. 10), for example, with the fitted brass infrastructure of the near-stool that holds together the shaky Shaker chair. The chair is falling apart; its center cannot hold. Its wood and rushes are far advanced in some direction that we may identify as centrifugal. The brass para-stool structure, however, is, by contrast, centripetal. It makes for the center that cannot hold, and holds it.

The place of (furniture) restoration in Gord Peteran's work (as opposed to "pure," *ex nihilo* creation) is, as Glenn Adamson points out in his essay in this volume, "another story." But the stories of Peteran's life and his work are always inextricably intertwined.

Peteran once mentioned in a letter to me that he "loved the process of restoration" and dilated upon that process as exemplified by the making of *Prosthetic*, which began, he noted, as a "rather humble example of a mid last century American shaker (style) chair," which was, unfortunately, beyond reasonable restoration. "There were major structural cracks in the chair and every joint was too loose to re-glue. It had taken its last breath," he told me.[3]

Its breath returned, however, in the course of the metamorphosis Peteran effected for it: "I chose to fortify it with a brace," he wrote, "while at the same time providing it with a new state of function. The 'stool' depends on the original wooden components, which in turn rely on the metal fittings to keep it rigid. This brass prosthetic can be removed without a trace, as it has not, at any point, entered the flesh."

The flesh? A chair that had taken its "last breath"? The brass near-stool prosthetic becomes an almost surgical intervention in the anthropomorphized body of the chair: a structural subordinate clause that commutes the sentence of the dying body.[4] I call

it rescue. Though of course you could see it the other way around—that the brass is actually plunder: inner wood and alien brass conflated, host and parasite.

At what price is the coherence of objects achieved? In his brilliant book about prosthesis and the prosthetic, David Wills makes note of the "abyssal indistinction" that occurs, in prosthesis, between "necessary" contrivance and "willful" artifice.[5] In Peteran's *Prosthetic* what "necessary" and compassionate contrivance fuels the rescue of the chair by the brass stool, and what "willful" impress of wit orders the chair's surrender to the imposition of the brass stool? And is their unexpected détente an exaltation of the whole ("only connect") or a pitiless sojourn in the realms of an ordering desire of the artist, where disparate things are yoked together by a kind of morphological violence? Is the chair a sort of constructivist *Laocoön*? Is the stool a medicine or a virus? A salve or an infection? Is the stool a perfect idea waiting to be born from the dissolving matrix of the chair, or a bristling structural impediment to the chair's natural swoon into dissolution? The chair's plight (or triumph) is close to that of poet Marianne Moore's famous fish:

All

external

 marks of abuse are present on this

defiant edifice—

all the physical features of

ac-

cident—lack

 of cornice, dynamite grooves, burns, and

 hatchet strokes, these things stand

 out on it; the chasm-side is

dead.

Repeated

 evidence has proved that it can live

 on what can not revive

 its youth.[6]

Peteran's chair cannot quite live "on what can not revive its youth," but it lives beside—or in conjunction with—what can revive it: the brass stool. The two make one system.[7] As David Wills points out, "prosthesis is inevitably about belonging."[8]

Distance

here is an element of dandyism (it lives in detailing) manifest in many of Gord Peteran's furniture-objects: a sweet yet almost satirical swoon toward what one might call decadence—but only if by using the word *decadence*, one is determined to fend off its cheaply acquired associations with burnout or fall, and cleave instead to its meanings as a word living, as Richard Gilman points out, "under the pressure of extreme consciousness."[9] It is fruitless to approach language as if it were settled (even with the aid of grammar as the prosthetic binding together of words and meanings). And so let us deliberately unsettle the word *decadence*, by using it as the poet Yeats used it: as a way of referring to what he called "the autumns of the body."[10]

A number of Peteran's works recede from the comfortable status quo of modernism, moving backward in time, coming to rest, finally, in a pseudo-archaic, distinctly autumnal past, rather than pushing forward into the scrutinizing, deconstructivist present. *An Early Table* (2004; cat. 18), for example—made one summer at the family cottage when, seized with the desire to make, Peteran frantically employed what easily fell to hand for building (twigs and string)—looks hoary with age and infirmity, festooned with string the way cypress trees are festooned with Spanish moss. The work does not deconstruct table-ness. It does not analyze. It aspires. Similarly, *A Table Made of Wood* (both versions, including the one with the contiguous wooden still-life vase) is an imprecise dream of a table, a positing of a table, an aggregate, Frankenstein's monster of a table, as redolent of pathos as it is bristling with the cheeky wit of reclamation.

These objects are historicizing toys, but they are saved from being marooned as marginalized furniture curiosities, as structural eccentricities floating on the river of time, by virtue of their almost alarming imminence. On the one hand, how insubstantial they seem! They are ethereal bodies, autumnal and full of yearning. And yet they burn with presence—like the "things of ether" in Wallace Stevens's poem:

> It is like a thing of ether that exists
> Almost as predicate. But it exists
> It exists, it is visible, it is, it is.[11]

Many of Peteran's pieces can be seen as models of a forgotten or misplaced corporality. There is an oldness, an antiqueness in some of them that confounds the (increasingly wearisome) dialectics of style and deposits them in some metaphysical time past: *An Early Knife* (fig. 9), for example, looks . . . well, *early*. Peteran may have been joking when he suggested to me

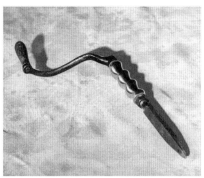

FIG. 9

Gord Peteran

An Early Knife

2004

(we were both hefting the knife) that "before they developed the edge tool, they had to kill people differently." But *An Early Knife* always looks to me like some implement you might pick up and play with from a table in Benvenuto Cellini's workshop.

So too does the artist's *Ark* generate a sort of Renaissance fragrance (not to mention the heady scent of Asian splendor), suggesting both sedan chair and confessional, both a moment of haughty privacy and the fleetingly claustrophobic echo of the torture chamber (after all, if you close the door tightly, there isn't a lot of air left inside). Indeed a good many of Peteran's productions—*Beam* (1999; cat. 7), for example, or the intricate, jewel-like musical astrolabe that is *Musical Box (Glenn Gould Prize)* (1996; cat. 4), or the exquisitely milled *Three Bronze Forms* (2002; cat. 15)—feel as if they might fit more seamlessly into the workshops of Kepler or Galileo than into the design department of the Museum of Modern Art. *Maypole*, though it possesses certain echoes of subversive Victoriana, might equally find its niche in some spidery corner of the halls of the Spanish Inquisition.

It's fanciful, I know, but whenever I look at Gord Peteran's exquisite stuff, I find it hard not to think of those two great engravings from 1514 by Albrecht Dürer: *Saint Jerome in His Study* and *Melencolia I* (fig. 10). You could easily insinuate something of Peteran's into the saint's febrile room, already replete with (in Erwin Panofsky's tally) "a pair of scales, an hourglass, a plane, a saw, a ruler, a pair of pincers, some crooked nails, a molder's form, a hammer, a small melting pot, a pair of tongs, an inkpot and

a pair of bellows, a turned sphere of wood."[12] And, wouldn't something of Peteran's fit comfortably—exquisitely—into the study of Dürer's troubled melancholic? Something that might sit majestically next to that truncated rhomboid?

Gary Michael Dault is a Toronto-based painter, poet, writer, and art critic. He writes two weekly columns for the *Globe and Mail*, Canada's national newspaper, contributes to international magazines, and is the author of numerous books and catalogues about contemporary art. He is an adjunct assistant professor at the University of Waterloo School of Architecture.

NOTES

1. "The greatest masterpiece," Jean Cocteau once remarked, "is never more than an alphabet in disorder" (Marie-Rose Carre, "René Crevel: Surrealism and the Individual," *Yale French Studies*, no. 31 [1964]: 74).

2. "Only connect! That was the whole of her sermon. Only connect the prose and the passion, and both will be exalted, and human love will be seen at its height. Live in fragments no longer. Only connect, and the beast and the monk, robbed of the isolation that is life to either, will die" (E. M. Forster, *Howards End* [New York: Modern Library, 1999], 170). It is amusing to note, by the way, that "Only Connect" is now a name shared by dozens of magazines, Web sites, multimedia companies, and "wireless living" services.

3. Gord Peteran, correspondence with the author.

4. "The Greek verb translated as 'restore,' as in 'mending,' *katartizo*, means also 'to complete thoroughly, i.e. repair or adjust—fit, frame, mend, (make) perfect (by joining together), prepare'" (David Wills, *Prosthesis* [Stanford: Stanford University Press, 1995], 109).

5. Ibid., 15.

6. Marianne Moore, "The Fish," in *The Complete Poems of Marianne Moore* (New York: Viking, 1967), 32–33.

7. Peteran once wrote me that there were two schools of thought when it came to restoration: "Complete renewal . . . and . . . left as close to 'as found' as possible. In a way, here [i.e., with *Prosthetic*], I think perhaps I utilized both to create this piece" (correspondence with the author).

8. Wills, *Prosthesis*, 15.

9. Richard Gilman, *Decadence: The Strange Life of an Epithet* (New York: Farrar, Straus & Giroux, 1979), 7.

10. William Butler Yeats, quoted ibid., 29.

11. Wallace Stevens, "The Auroras of Autumn," in *The Collected Poems of Wallace Stevens* (New York: Knopf, 1961), 418.

12. Erwin Panofsky, *Albrecht Dürer* (Princeton: Princeton University Press, 1945), vol. 1, 156.

FIGURES

FIG. 9
Gord Peteran (Canadian, b. 1956)
An Early Knife, 2004
Found steel handle, found steel blade
18 in. (45.7 cm) long

FIG. 10
Albrecht Dürer (German, 1471–1528)
Melencolia I, 1514
Engraving
9 5/16 x 7 1/4 in. (23.7 x 18.4 cm)
Milwaukee Art Museum, Gift of Mrs. Albert O. Trostel Jr., M1967.6

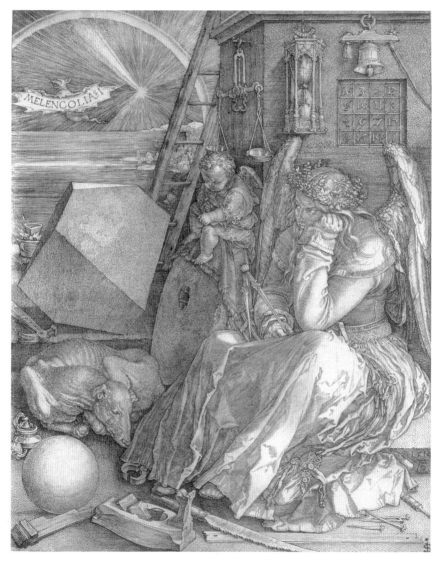

FIG. 10

Albrecht
Dürer

Melencolia I

1514

"We understand the invisible objects perfectly,

because we've been studying them since birth.

It's the visible objects that confound us.

They're much harder to grasp because they exist

in a present encounter—they're new information.

They're foreign information."

—G.P.

PETERAN 92

Objectology
An Ongoing Debate between David Dorenbaum and Gord Peteran

Reprinted from Peter Fleming, ed.,
Reflections on Furniture: The Body Double
(Toronto: Ontario Crafts Council, 2005),
by permission of the publisher.

Spadina—Dupont **Dorenbaum's view**

Some afternoons in the course of my work at the office I escape to Gord Peteran's studio on Dupont Street. Working all day as a psychoanalyst can be very demanding. Sitting on my chair listening to my patients with "the third ear" both captivates me, and also makes me want to get out. Gord and I share a peculiar interest in objects. The object for a psychoanalyst is understood in a sense comparable to the one it has in the literary, as in "the object of my passion, of my hatred, etc." It does not imply, as it does ordinarily, the idea of a "thing" or a manipulable object only. But where to go from there? I go to see Gord, the only person at the only place where I am sure that our conversation will not get us anywhere, or at least anywhere predictable. Nothing will be resolved. No matter what the stated intention, each conclusion leads us to more fantastic questions. Then time is up and I have to race back to Spadina Road and once again assume the position of the psychoanalyst.

You have to realize that over the years, in the course of our knowing each other, I have commissioned Gord to make a bookshelf that turned out to be the perfect piece. We have also collaborated during three consecutive years to give a class at the Ontario College of Art and Design; Gord invited me to participate at the Furniture Society conference in 2000 and he has been a guest speaker at the Department of Psychiatry, University of Toronto, where I work. I find objects and leave them outside his studio or under his door. He leaves me countless messages on my answering machine with thoughts. Surreptitiously we arrive at places that we would have never imagined. Everything that has come out of our meanderings together leaves us wondering if we will ever get to the point. How can we tackle the "thingness" of things? Unlike butterfly collectors, in an act of complicity we both agree not to pin down the object.

To give you an example of something that is currently happening, some years ago a patient of mine in the course of his psychoanalysis broke the rib of a chair in my office. The patient came to see me at a time in his life when parts of his body were breaking. Hard as it was for me to hear the "crack" of this rib, I felt this incident with

the chair was at the heart of my patient's story. In despair about the broken chair I called Gord for help.

Gord fashioned a precise bloodwood splint inlaid along the underside of the broken member. He tightly wrapped the wound with fine gold thread. Gord's intervention left me feeling that this chair, which had always been very dear to me, was now improved as it contained the traces of a significant event. I later discovered that the designer of the Milano chair, Aldo Rossi, an architect from Milan, had suffered many injuries during his life and that he had a kind of attraction for broken things.

Five years went by. One afternoon Gord arrived at my office and in the course of our conversation he noted that the same rib of the chair had experienced another break next to the repair. I hadn't been aware of it. This observation took me by surprise. In an act of immediate denial I blamed Gord for having produced the second break then and there! Five years after the first incident, I saw myself taking the chair to Gord's studio for a second time. Clearly the intervention this time would have had to take into consideration that neither Gord, myself, our friendship, nor the chair were at the point that we had all been five years earlier. Time had gone by. Gord no longer treated me like a client. He invited me into a collaboration.

We began by taking the chair for consultation to the senior students of the Industrial Design Program at the College where we were teaching a course called Advanced Visual Language. We requested that the students give us their opinion on what to do with the broken chair. We were amazed by the resolutions suggested by them. I wondered what effect they would have on us.

Gord handed me a small black sketchbook. He later confessed to me that he had hoped that the book would harness some of our ideas. According to him, this book would embody our collaboration, as we had a place to document our ideas about the chair and what to do with it. The book already contained some detailed diagrams and drawings that he had made. In the meantime the chair remained in Gord's studio on Dupont Street.

The other afternoon I escaped to Gord's studio and brought some soup for us. Gently he directed me to the back door, close to the train tracks. To my surprise I saw some smoke. Fragments of the chair were burning. Gord had disassembled the chair and begun to burn it. He handed me a note.

> David,
> Are you brave enough to accept that you will never get your chair back?
> To move ahead we need to let go. I have exorcised your demon.

I couldn't believe what my eyes were seeing. The partly recognizable remains of my chair which had turned into charcoal and ashes left me in awe. We proceeded to have our soup. I knew that if Gord had used this technique to repair the first break, the second break would not have happened. But neither would we have traveled this distance! This time around, as the chair was burning in front of our eyes, Gord and I both felt the emergence of an object: the object of our no-point conversations, the one that we are really after, the elusive, never-to-be-taken-for-granted object. There it was, more present than ever . . .

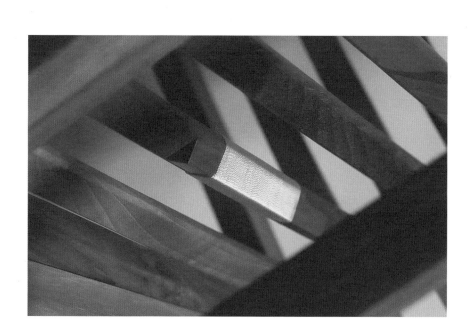

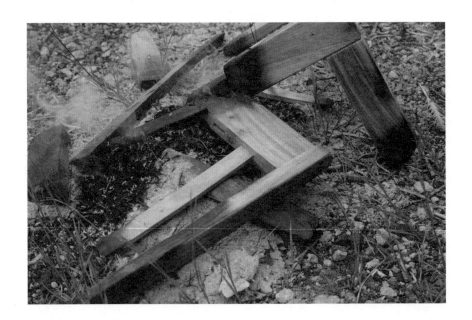

Dupont—Spadina **Peteran's view**

ell, that may be true, but I burnt David's precious, little, fancy pants, Italian architect-designed chair for a reason. I felt he was asking me for the "object" that all of my clients were asking me for. In order to discover what it was, we needed to back up to the point before the chair's arrival, to the anti-object, to the pre-object.

I have lost sight of where we end and objects begin. Over the last few years my work has become less and less about furniture as an object, becoming more and more about furniture as a subject. It interacts with us and with our bodies in an especially curious, mostly non-physical way. The relationship is greatly amplified by the transference of ownership. David and I share a suspicion of objects. A drawing remains in the realm of ideas. Objects are more blunt, more factual. Only now, after having completed many commissioned projects for clients, do I realize how treacherous the constructed form standing in real space can be.

Before making furniture I was restoring furniture. Now I wonder if there is a difference. I have sold many strange things to perfectly respectable people under the auspices of a furniture commission, but I can barely consider these objects "furnitural" in nature. David's bookshelf, for example, has never contained any books. The client of the last table I delivered told me with glee that "it repelled any object he tried to place upon it." What other service, then, must I be providing?

I have noticed numerous similarities between the doctor's practice and my own. We both seem to pay attention to the therapeutic patterning with regard to people and their possessions/baggage. I, too, listen carefully to my clients as I believe this can provide a more potent solution. If one is honest, one will hear what the client wants to reveal, and also what they do not. A prescription develops during these conversations. It forges an irreversible form to the object that will eventually be taken from me. And so begins the treachery of the object.

Clients return to me for additional purchases. In these requests, I observe fundamental requirements that repeat themselves even though the form of the object has changed. Perhaps it is in this sameness that the roots of an addiction are evidenced. David and I have agreed on the diabolical nature of people's attraction to objects, and

about the resulting crushing possessiveness. Extensive discussions take place in our classroom. Nicola, one of our students, cleverly coined the term "objectology." I imagine that, if left untreated, the case of David's chair would eventually lead to "objectosis," a severely disfiguring state!

Over the years I have gotten to know David well and to respect his passion for the contemporary arts. This chair was one of his prized possessions. His first call for help with the "chair issue" was an attractive proposition, but his reaction to the second break revealed symptoms of a much juicier challenge for this craftsman. Previously the woodworker in me tried as avidly as I could to convince him that the short grain in the seat's rib members was a design flaw, that this was a casualty waiting to happen. David acknowledged this but would not be dissuaded. From his reality, he could only see the snap having taken place at the exact moment that his patient with the disintegrating body sat down. When it broke for a second time so close to the first break he accused me! David also attempted to link the breaks with Aldo Rossi's fixation with "broken things." At that point I began to expand my focus on the wounded chair to include its . . . custodian. I could see that for David the "object" no longer resided solely within the chair.

At the Ontario College of Art and Design, our fourth year students came up with a stream of brilliant repair solutions. Each student acknowledged the substantial number of collateral issues surrounding this object. Our conversations only reinforced the hunch lurking in the back of my mind, that David and I might both have to confront the issue with our years of conversation as arsenal.

What exactly does a client's request embody? Can one ever satisfy this request with a significant enough object? I am beginning to suspect that the whole deal is about restoring something the client, perhaps unconsciously, feels is missing. David's dilemma presented ideal conditions for a controlled experiment. I began from the notion that often objects can act as premature pin cushions for our desires. My first intervention was to eradicate permanently this "object of desire" from David's line of vision. We would then be able to see if it was possible to reinstate it or at least trace the trajectory of its initial arrival.

When I can, I go for the jugular. I decided to pounce and invited David over for lunch at the studio. He brought soup. It was very good. A meal of many courses was to follow. Presently the little black book filled with arrows pointing at the subject sits in my studio.

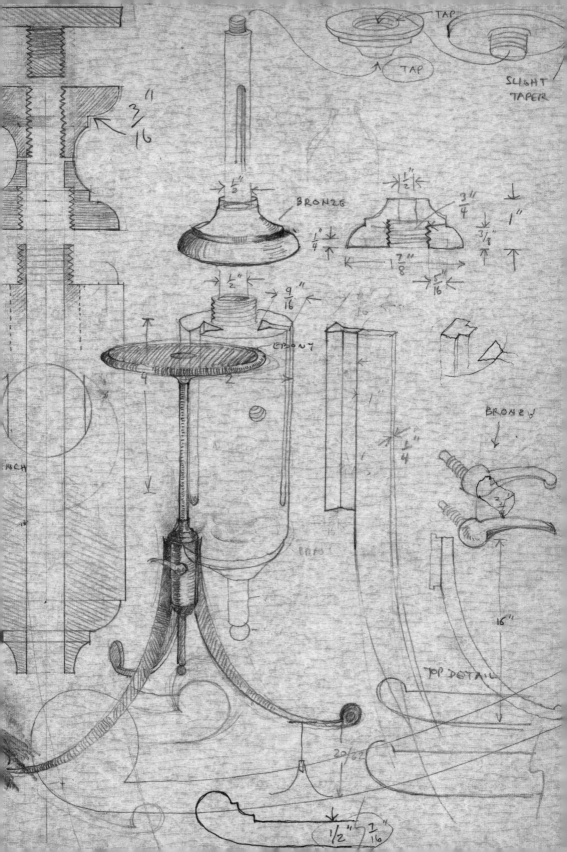

TAP

TAP

SLIGHT
TAPER

$\frac{3}{16}$"

BRONZE

$\frac{1}{2}$"

$\frac{1}{4}$"

$\frac{1}{2}$"

$\frac{3}{4}$"

1"

$\frac{3}{8}$"

$1\frac{7}{8}$"

$\frac{5}{16}$"

$\frac{1}{2}$"

$\frac{9}{16}$"

EBONY

4

2

1"

$\frac{1}{4}$"

BRONZE

EBONY

TOP DETAIL

16"

20/62

$\frac{1}{2}$" $\frac{7}{16}$"

Works

Chair with Arms, c. 1977

CAT. 1 Found chair with carved walnut alterations

34 3/4 x 28 x 33 in. (88.3 x 71.1 x 83.8 cm)

 eteran acquired many of his woodworking skills, and much of his attitude toward furniture, while working in his uncle's antique store. Though only a teenager, he was entrusted with general repair of items that came into the shop. His earliest extant piece of furniture, *Chair with Arms*, was made in this environment around 1977, though it could well have been earlier. Peteran recalls the making of it as somewhat casual but at the same time instinctive and profound—a primal encounter. It was, he says, "my first experience of the kind of impact the third dimension could have." A "picker" had brought his uncle the simple old frame of a rocking chair on the back of a truck. Peteran, who had been steadily honing his carving skills, made a pair of hands for the chair's arms—a simple enough joke, but also a weirdly prescient gesture, given the unsettling anthropomorphism of many of his mature works. At his request, his mother created needlepoint upholstery for the chair's back and seat.

By Peteran's own estimation, the power of the finished chair is that it is not a representation, but rather an object that exists entirely on its terms: "When you're working in three dimensions, there's no room for 'things appear to be.' I simply replaced what I felt, at the time, the object was missing." Every functional object constitutes a reality of its own, which, in a unique blend of ingratiation and defiance, enters immediately into a relationship with the reality of its user. These are grounds for a confrontation—one that, thirty years on, continues to fuel Peteran's work and thinking.

"I started making the things

I was tired of looking for."

—G.P.

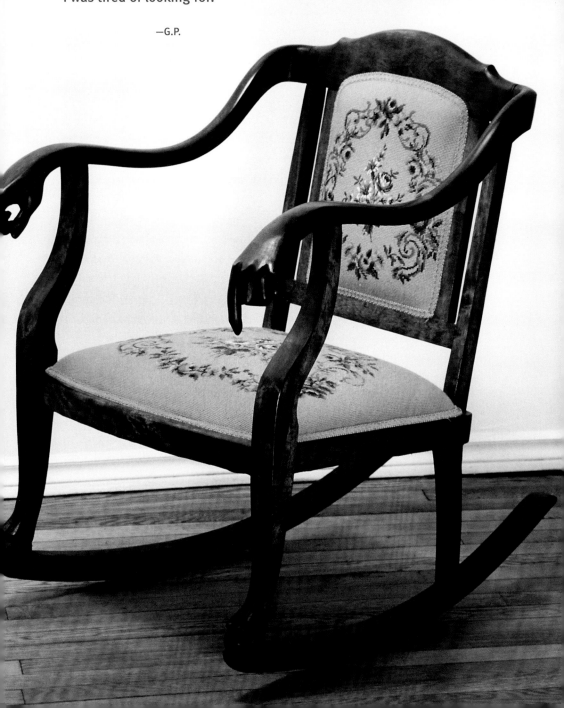

Chest on Chest, 1984

CAT. 2 Red oak, ebonized cherry

Two parts: 40 x 32 x 19 in. (101.6 x 81.3 x 48.3 cm), 10 x 8 x 3 3/4 in. (25.4 x 20.3 x 9.5 cm)

Collection of David G. Burry

I n 1984 Gord Peteran was five years out of his art school training at the Ontario College of Art. While enrolled there, he had continued to work in wood, studying with a skilled Italian cabinetmaker named George Giannone and with Michael Harmes, who had been on the staff at the School for American Craftsmen in Rochester, New York. Peteran says: "It was during this same time that I was working for my uncle and his neighbour in the historical thing. Something important was happening here; while they were teaching me one thing I was actually learning another." The first piece of furniture he sold—making him, by definition but perhaps unexpectedly, a professional furniture maker—was a simple chest of drawers, surmounted by an exact duplicate of itself in exactly one-quarter scale. The larger of the two chests was made first, followed by its "model," inverting the usual cabinetmaker's procedure of making a miniature version of a piece to work out design and construction details. The design itself is devoid of conspicuous styling, apart from pointy feet, which could be seen as either sprightly or malevolent, depending on one's disposition. When stacked one atop the other, the two objects create a curious perspectival effect, as if a single chest were both close at hand and far off in the distance.

Peteran has recently written of this piece: "I find it curious that I would still stand behind it. I was grasping at something that became quite real for me." This seems about right. Though *Chest on Chest* is a designed object to an extent that is quite foreign to Peteran's current practice, it can be seen in retrospect as a strong indication of his later artistic strategies. Its title exactly describes the work, as with *A Table Made of Wood* (cat. 8) or *A Little Table* (cat. 13), and as is universally true of his recent work, the reductive conception of the piece, the minimal nature of the proposition, is extreme. It suggests only the crucial idea that a piece of furniture can exist in metarelationship to itself. It does so simply, through imagery rather than concept, but nonetheless it is a young maker's work that shows strong signs of what was to come.

"That's a piece where I did

almost nothing."

—G.P.

Boardroom Door, 1990

CAT. 3

Red oak, brass, oil paint, etc. ("just about every material there is")

108 x 70 7/8 x 8 in. (274 x 180 x 20.3 cm)

Collection of the Ontario Crafts Council

or a long time Peteran was not particularly concerned with furniture. He was primarily a "public artist," a role in which he is adept. Navigating the obligations and compromises of public work comes easily to him, and he still frequently creates large-scale commissions, particularly in Toronto. He has said that "clear boundaries are what interest me," and while the limitations on his work have been increasingly self-imposed in recent years, the demands of particular public contexts can play a similar role for him. Among his works in this vein are a monumental clock now in Toronto's Metro City Hall (fig. 11), several portals for public and domestic spaces (figs. 12 and 13), and numerous ecclesiastical commissions. In most of these projects, he employed a great deal of evocative imagery: birds, faces, and other easily grasped symbols. He concedes in retrospect that these touches may seem "somewhat hokey" but also notes that they serve as a "gentle invitation" for the viewer, who might well be left cold by clinically conceptual work.

This iconographically oriented strategy is on full display in Peteran's most impressive public work, an oak door for the Ontario Craft Council. The fine art journalist Betty Ann Jordan has called the door "a Rosetta stone for Canadian craft, evoking the spectrum of arts, crafts and trades,"[1] and at first it does seem to be simply that. A silhouette map of Canada anchors the composition, and the door includes numerous allusions to the variety and richness of craft traditions. Woodwork is a central subject: linenfold carving like that on Elizabethan interior paneling, a gorgeous bit of ornamental leaf carving, the nuanced curves of a fiddle, a compass, and a measured molding profile are among the motifs. There is also a welter of clever puns and spatial games, with numerous nonfunctional keyholes, small doors, and drawers set within the larger doorway, a handle in the shape of a key, and most winningly, a functional clock whose pendulum hangs one panel below the face to which it is connected. A palette and a portrait imply an equivalence between craft techniques and painting (one of Peteran's favorite subjects; he has said that "woodworking and metalworking are my paints and brushes").

"Ironically, around town

I'm known as the door man . . .

Entrance / Exit."

—G.P.

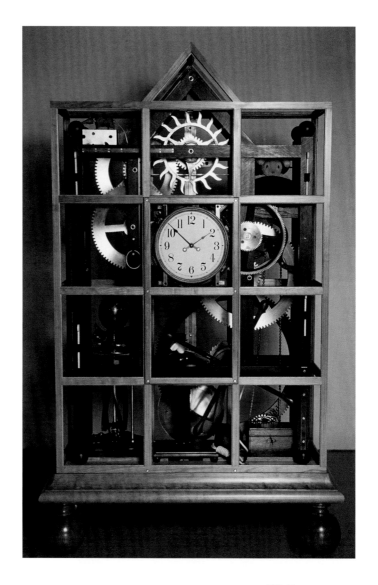

FIG. 11

Clock

1992

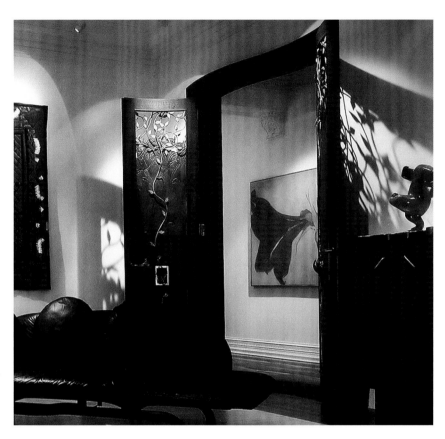

FIG. 12

Chestnut Park Doors

1991

FIG. 13

Chestnut Park Doors (detail)

1991

Musical Box (Glenn Gould Prize), 1996

CAT. 4 Red oak, brown oak, steel, ebony, brass, aluminum, plastic, leather, rock, copper

5 7/8 x 29 1/2 x 19 5/8 in. (15 x 75 x 50 cm)

Glenn Gould Foundation and Glenn Gould Studio

 very three years the Glenn Gould Foundation, a Canadian charitable organization devoted to the memory of the great pianist, gives an award to an individual who has made a signal contribution to the world of music. In addition to a significant financial prize, the recipient is also given an original work of art. In 1996, as a result of his successful career in public art, Peteran was selected to create an artwork to be given to that year's winner, the Japanese composer Toru Takemitsu. Sadly, Takemitsu passed away shortly after the announcement of the award, and the object Peteran eventually created, *Musical Box*, was retained by the foundation.

As soon as Peteran began thinking about the commission, he considered the question of what distinguishes music from sound. He was puzzled by how "the process of manipulating raw sounds into a different order of raw sounds somehow creates music." He made a machine for testing this phenomenon, a contraption that, as he concisely puts it, "makes seven stupid sounds, all different." Its mechanisms are each operated by a brass and ebony knob, but there the unity of the construction ends. One of its internal devices is a globe containing smooth rocks from the bottom of a fish tank, which swish together when the globe is turned. There is a crude xylophone, an even cruder geared music box, a contraption consisting of different lengths of metal rod that strike a piece of plastic when they are rotated, and a reed sounded by a homemade bellows. Turn another knob, and a single string is plucked by a Fender guitar pick. Though Peteran professes to be "a guy who knows nothing about music," there is a sly mimicry here of the many voices of an orchestra in the box—it has elements of percussion, reed, string, and keyboard instruments, and ends in a spring reminiscent of a fiddle's head. The top is hinged, admitting a view of the interior and its secrets. Taken as a whole, the instrument is equal parts Rube Goldberg and John Cage. It does for music what Peteran's work normally does for furniture—isolating the medium's basic premises and freezing them in a state of arrested development.

"It quickly asks the question—

the only question—

what are we doing?"

—G.P.

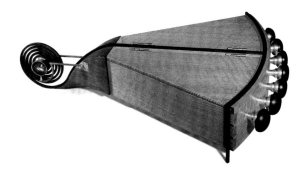

100, 1996

CAT. 5 Machined bronze, ebony, custom-built oak and leather case

Table: 27 x 27 x 27 in. (68.6 x 68.6 x 68.6 cm)

Case: 5 x 27 x 18 in. (12.7 x 68.6 x 45.7 cm)

Collection of Sylvia and Garry Knox Bennett

 he title *100*, like most of Peteran's titles, is quite literal. It was the one hundredth object that he managed to sell. This statistic may have been an achievement of sorts, but it was nothing compared with the work itself. Peteran's career can be neatly divided into two periods, before and after *100*—it constitutes that much of a turning point in his way of thinking about furniture, through furniture.

It consists of a pair of identical tables, one of which is normally displayed in a disassembled state, packed into a custom-built, leather-lined case. The parts of the two tables are interchangeable, the bronze and wood parts shaped to extraordinarily tight dimensional tolerances on equipment belonging to a friendly Toronto machinist. "Ideally," Peteran has written, "the owner of *100* will experience both the structural system as it relates to 'elegance,' and the trust that 'the perfect' can provide with units milled to one-thousandths of an inch." The work is indeed formally elegant, but more importantly, in its exactitude it seems implicitly dangerous. The metaphor of a gun leaps immediately to mind when *100* is first encountered, at first simply because of the combination of dull black metal and polished wood, and then because of the carrying case. Those interchangeable parts, too, connect the work back to Eli Whitney's Connecticut rifles. If *100* is analogous to a rifle, perhaps this is because Peteran himself was now thinking of himself as something of a sniper—targeted and precise, camped on the edges of the furniture field and choosing his spots.

The title of the work, though it refers explicitly to a benchmark in Peteran's career, also hints (perhaps inadvertently) at the subject of the piece: mass production. *100* stakes out the minimum difference between the unique, hand-wrought object and the series of identical commodities. It brings those two oppositional poles so close together that they nearly touch, and it exists in the infinitesimal space left between them. This leads to the obvious question: if the tables were manufactured through the investment of hours and hours of laborious setting up and calibration on expensive replicating tools, then why are there only two of them? It is almost as if, by concentrating the

"I employ the kinds of things

I can control

to pursue the things that

elude me."

—G.P.

productive capacity required to make a hundred or a million objects into only a pair, Peteran had hoped to create an experience of unusual intensity. This is of course irrational on the face of it, but the absurdity anchors a set of ideas about practice that is entirely cogent. A reversal of priorities has occurred: the productive system of *100* is drastically out of scale with its actual requirements. Because of this fundamental asymmetry, though, that system takes on an autonomy of its own. What is important about *100* is not that it is the product of a deliberately underutilized means of fabrication. Rather, it is that the work itself produces such a system in the imaginary. This intangible system and its corollaries (its emotional overtones of churning industry, its antithetical relation to the limited means of the studio artist) exist only in the mind as a conceptual outcome, not a literal phenomenon.

100, then, was a step forward for Peteran in ways that transcend its content and aesthetic. It was the first of his works in which a uniform conception was equally present at every level of manufacture and form. This made the imagery that sometimes ran rampant in his earlier work unnecessary, and established a clarity of effect that constitutes its own powerful aesthetic. *100* is the first object that Peteran conceived of as an instrument, finely tuned and stripped bare. This idea is implicit in *Musical Box* of the same year (cat. 4), but that object is literally performative and so carries its conceptual weight more winningly. *100* is a tougher work by far. It simply sits there; it can be taken apart and put back together again, but otherwise it does no tricks.

Another question: if *100* could be created in relation to production, what other "furni-tural" topics might also be fair game? The implication of *100* is that similar conceptual operations might be possible with regard to form, function, architectural context, even with the "body" that might interact with a furniture form. In Peteran's earlier works, these issues had certainly been present. Sometimes they were even addressed directly as a metasubject, through the clever use of style and image. But what if such "furnitural" subjects were instead detached abstractions, floating free and ready to take on a life of their own? Seen this way, furniture might become the launch pad for experiments; its qualities might be pushed to extremes, both maximal and minimal, just to see what might happen. And this of course is exactly the conclusion that Peteran reached. The title of *100* looked back, retrospectively, on a reasonably successful career. But the object itself opened the door to a practice of a different order entirely.

Untitled So Far, 1996

CAT. 6 Found wood turning, red leather, linen thread

20 x 7 x 7 in. (50.8 x 17.8 x 17.8 cm)

Wood Turning Center Collection, donated by Albert and Tina LeCoff

 urning—a craft discipline that involves creating objects on the lathe, usually from wood—has a unique place in Peteran's work. He does not consider himself a turner in any way. When *Untitled So Far*, his earliest foray into the medium, was featured in two major touring exhibitions about contemporary wood turning, he was bemused: "One stolen attempt at lathe turning, covered in some old cow hide then left to rot, does not a turner make." Yet this strange object is among his most affecting works. It began its life at a residency program in Canada, where another artist turned a simple spindle shape on the lathe and then discarded it. Peteran plucked the fragment from the woodpile, wrapped it in a sheath of red leather, and carefully stitched it up. The result is an obviously phallic form that contains within it a pointed critique of the turning field. The leather cover could be read as a rejection of the turner's standard adherence to the beauty of material, or even as a satire on the unseemly preciousness of turned objects, which (like "glass art" before them) currently threaten to become so successful as commodities that any internal artistic discourse that they might support is sidelined. *Untitled So Far* makes it clear what the transformation from a functional turning into an objet d'art necessarily entails. A museum pedestal removes an object from the realm of the tactile; like the work's red leather cover, it withholds at the same time that it glorifies.

Such a didactic interpretation of the piece, however, seems somewhat forced. Peteran certainly bears no personal animus against turners, individually or as a field, and in any case he is more interested in defamiliarizing the everyday object than in critiquing the work of other artists. The historical antecedents for *Untitled So Far* head (perhaps via Christo) in the direction of Dada and Surrealism, but it is the playful weirdness of Man Ray rather than the institutional undermining of Marcel Duchamp that Peteran is channeling. His subsequent engagements with turning have had a similarly mischievous, and at times even affectionate, quality; in the comparatively confined world of turning, he has found a ready laboratory for his experiments. Following the notoriety of *Untitled So Far*, he was invited to participate in another residency, this one hosted

"The turning field is a microcosm

of every other subject in the arts.

And we're able to catch it at its inception,

is what I'm thinking.

We get to study the raw formation

of a field."

—G.P.

Beam, 1999

CAT. 7 Oak, brass

26 1/2 x 15 x 111 in. (67.3 x 38.1 x 282 cm)

Collection of William Anderson

eam is a simple wooden bar, triangular in cross section, with two sliding attachments in the form of a prop and a round. When assembled, the whole affair is like a seesaw for one. Stylistically it can be seen as a direct descendant of *100* (cat. 5) in its precisely machined parts and its evidently collapsible construction, which implies some level of portability. But whereas *100* is an ineffable work of conceptual art in table form, *Beam* is more limited in its scope. It directly addresses the matter of furniture design. Peteran has radically simplified and then reshuffled the components of modernist seating—vertical support, horizontal cantilever, and a perch for the body—with each element given a simple geometrical identity (rectangle, triangle, circle). These functions are somewhat independent of one another in that, within the limits of counterbalancing, the parts can be moved around with respect to one another, creating different seat heights and compositional angles. With a slight shift in composition, the object can be made to seem more a table than a chair. Or *Beam* can be taken apart entirely, in which case one is left with three strange items: a brass and wood sculpture, a perforated plank, and a long lever. What might one do with these things? Peteran leaves that to the imagination.

"People say, 'what's that?' So I say

'that's furniture, not sculpture,'

and see what they do next."

—G.P.

A Table Made of Wood, 1999

CAT. 8 Various woods

31 x 37 x 14 in. (78.7 x 94 x 35.6 cm)

 Table Made of Wood is a work about pressure. Its form, first of all, seems to exist in a steady state of equilibrium between visible internal entropy and invisible exterior force. No means of joinery is evident; it is as if the piece is held together by the will of its maker, rather than through any literal application of craft. *A Table Made of Wood* is also pressured by its flat-footed title. This is an object that is exactly what it is described to be, no more than that—and perhaps even a little bit less. As Peteran implies in his précis of the work, it is fundamentally a pile of scrap. That it exists at all is, as is so often the case in his work, a matter of bemused determination. Ultimately the pressure being exerted on this table is of the most fundamental kind: the pressure to create something worthwhile from the least promising of circumstances.

Curiously, though the table is not the most provocative entry in Peteran's portfolio by any means, it produced the only certifiable controversy of his career. An image of the piece in the October 2003 issue of the West Coast magazine *Woodwork* incited an angry letter to the editor from the period reproduction maker John McAlister—"What possibly goes through the mind of a guy planning and building such a thing?"— followed by a spate of further correspondence from readers. Some were horrified by the object ("with enough glue and kindling wood, you can make just about anything, but I'd rather light a fire with it than waste all that glue"), while others supported it ("I believe the guy is an artist"). One observant letter writer pointed to the work's resemblance to a chic icon of recent postmodern furniture, the *Favela Chair* (fig. 18).[2] This design existed in handmade prototypes made in Brazil by the brothers Fernando and Humberto Campana as early as 1991 but was not produced for mass circulation by Edra until 2003. Comparison with *A Table Made of Wood* is revealing. The Campanas' title refers to the shantytowns of São Paulo, but it is made of bland bits that are identical in color and finish, like so much mass-produced kindling bought at a supermarket. Its angled pieces too resolve into a planar, boxy form. Even though they are hand-glued and nailed, it is as if they had been poured into a mold. Each of the constituent fragments of Peteran's table, in contrast, bears the marks of its own

"The directive behind this piece was to try and capture the essence of furniture: to capture the history, structural substance, and poetry of the object in a more vital, gestural way. Standing in the neutral territory between the revered and the rejected, this table relies heavily on the individual's recollection of furniture—specifically, the classical D-shaped or demilune tables—as well as their recollection of . . . junk."

—G.P.

individual history. The whole composition has a sketched, improvisational character. "Labor can kill a work," Peteran has written. "In this piece, I started at one corner and worked right through to the other side, wanting to make something that would be quick and impressionistic—like my paintings."

In fact, this is one piece that Peteran has found to be worth making many times, each iteration different from the rest (fig. 19). One recent version is held together, according to the artist, "desperately, by odd sizes and shapes of screws often splitting the wood upon entry." All this is to say that while the Brazilian chair is a design solution, resolved and confident in its aesthetic, *A Table Made of Wood* and its successors are statements of an ongoing problem: creatures of an uncertain studio environment in which every object barely fights its way into being.

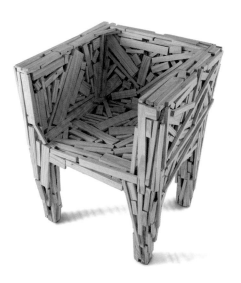

FIG. 18

Fernando and Humberto Campana

Favela Chair

1991

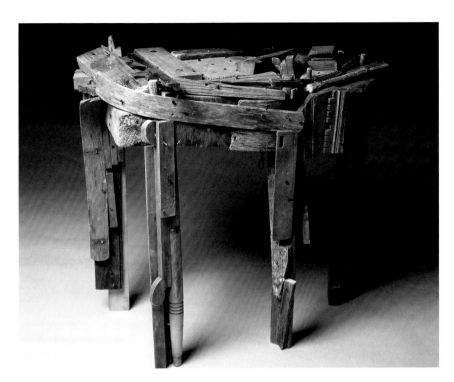

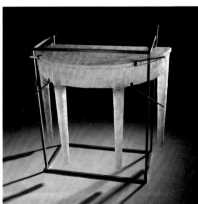

FIG. 19

A Table Made of Wood

2005

FIG. 20

Suspended Table

2005

Ark, 2001

CAT. 9 Stained oak, metal, velvet, glass, electrical cord

72 x 42 x 25 in. (182.9 x 106.7 x 63.5 cm)

rk is Peteran's most complex, multidetermined, and monumental work. Although unified compositionally, it is packed with incident. The quarter-sawn red oak panels that define the exterior tilt at unexpected angles, each one with a slightly different configuration of slanted framing elements. Bronze rings top each corner, suggesting that the whole work is meant to be portable despite its size, perhaps through the agency of ceremonial bearers armed with long poles. The interior is luxuriously upholstered in plush, hand-tufted red velvet. The overall form brings to mind a bewildering variety of furniture-related precedents: a sedan chair, a confessional, a throne, a stagecoach, a psychiatrist's couch, a phone booth, and even an electric chair—the last association being driven home by the mysterious black cord that snakes away from the piece to a nearby wall outlet.

The dominant historical antecedent for *Ark*, though, is the specimen cabinet, familiar from museums that display botanical, zoological, and anthropological samples. This was clearest in the work's original exhibition context—a group show of work by furniture makers and designers entitled *Comfort*, held at the Harbourfront Centre in Toronto. The thematic focus of the show directed attention to the way that *Ark* addresses the body. When a person enters the object, sits down, and closes the door, an overhead light automatically illuminates. Suddenly the user is put on view, enclosed in a luxurious but airless chamber. When in use, *Ark* becomes a double-edged and many-layered metaphor that calls forth numerous oppositions: exhibitionism and privacy, coziness and claustrophobia, display and functionality, privilege and death. The work is a memento mori, a surprisingly rare thing in furniture given that the history of the medium is so intimately bound up with prestige and vanity. Peteran never engages directly in social commentary, but if there is a statement on the subject of class in his work, then *Ark* is probably it. To be comfortable sitting inside this cabinet, on display in the middle of an art gallery, would be unthinkably narcissistic. What does *Ark* have, though, that a throne does not? Only its glass walls. In making the point that comfort (like knowledge) is inseparable from power, Peteran once again cuts to the chase: furniture is all a matter of where you're sitting.

"For the body to function

it needs vast amounts of resistance,

as does the intellect. . . .

The only comfortable place

is in the grave."

—G.P.

Prosthetic, 2001

CAT. 10 Found wooden chair, brass

36 x 17 x 17 in. (91.4 x 43.2 x 43.2 cm)

Collection of Douglas Nielsen

eteran's grandfather was an amateur cabinetmaker, who at one point made orthopedic devices for patients at Toronto's Hospital for Sick Children. This biographical detail raises the possibility that *Prosthetic* might be a self-portrait. This is not an obvious reading; the most evident subject matter of the work is restoration. Instead of upholstery, Peteran gives us "upholdstery," a reversible solution that preserves a historical artifact while giving it a new lease on life. But if Peteran's line of work has to do with maintaining furniture in its moment of demise, then *Prosthetic* certainly comes across as a signature object.

What Peteran has actually made, in formal terms, is entirely compensatory. The asymmetrical brass construct that grapples the found, broken chair is itself a diagnostic expression of the "patient's" precise injuries. Lateral and vertical forces are exerted where necessary, tightened rings bind splitting wood together, and the shattered rush seat is echoed by a cobbled-together brass circle that floats above it, slightly off-center. *Prosthetic* is, then, an analytic and reactive object. The chair's weak points are specified and addressed in a manner that seems simultaneously sensitive and hostile. Each interaction between brass and wood is lovingly crafted but also a point of attack. As much could be said for Peteran's work in general. Taken as a whole, his oeuvre could be said to be a prosthetic applied to the category of furniture: life support for a patient who may not make it in the punishing domain of contemporary postconceptual art. As in the nursing home, the right thing to do is to see how much life can be reclaimed from that which is old and worn. Peteran can't make furniture (or the ideas that are proper to it) young again. But in propping up this medium through one act of desperation after another, he has made it seem a newly viable enterprise, after all and in spite of itself.

"Each year amid the chaos and carnage of life, I like to restore an old piece. It's an enjoyable process that provides a certain kind of form and technique investigation I thrive on. I feel like I have saved something, brought it back into service from the past.

"This rather average example of a mid-19th century ladder-back, Shaker style chair was far beyond salvation. The feet had been cut down to the point that the bottom back two dowel joints were ruined, the back right leg was split to rat shit, the seat (out of which a dead mouse fell on to my studio floor upon arrival) was long gone, and every joint was loose beyond repair, normally falling within the category of 'not worth it.'

"I set myself the challenge of 'restoring' my neglected, forlorn little friend. The wooden structure was fitted with metal braces wherever necessary while at the same time causing the required surface to be 24" above grade. This prosthetic made from bits and pieces of brass I had around the shop does not enter the flesh of the patient and is fully reversible if necessary. The chair is now completely rigid while the brace is attached, the stool's surface is attained, although rather desperately, while feeding on the substructure of the ladder back chair."

—G.P.

Best General View, 2002

CAT. 11 Found wood, brass

42 x 36 x 15 in. (106.7 x 91.4 x 38.1 cm)

Collection of William Anderson

or Peteran, limitations on the creative process are crucial—they provide the friction necessary to the production of sparks. The patron is the ultimate embodiment of such constraint. All the psychological frailty of the client as an individual, and of the client and artist's relation to each other, is manifested through any work. To borrow a term from the lexicon of Freudian theory, it might be said that art constitutes a "cathexis"—a site of transference, a focal point for the libidinal energy and inchoate desire that motivate the choice to own something in the first place. Peteran takes this process very seriously. For him, the fact of possession finishes off the artistic gesture: "When people take ownership of my work, the piece is then complete."

Peteran has two clients of particular note, who function almost as collaborators for him. One is his analyst, David Dorenbaum (see "Letter of Reference for Gord Peteran" and "Objectology," in this volume); the table entitled *Best General View* belongs to the other one, William Anderson. Or rather, one version of it does. The second version is a permanent fixture in Peteran's home. The two tables exist in symbiosis, making between them one work. They implicitly regard each other, Peteran has said, "like a sight in a gun." Other metaphors might include the lenses of two facing cameras or telescopes, or perhaps, given the rectangular frames, two mirrors reflecting each other into infinity. Fittingly, the project had its origins in a dark alley. Peteran decided that "whatever was in the dumpster that night had to make two objects," which would address the relation between himself and a client. The tables themselves bear ample evidence of their casual manufacture—they lack even the gravitational energy of *A Table Made of Wood* (cat. 8) and are little more than plinths for the frames mounted atop them. And yet if those frames, and the two-way monitoring over a distance that they suggest, are a metaphor for the relationship between patron and artist, then the tables serve to capture that narrative within another framework: that of furniture. Peteran often speaks of forms like tables and chairs as "infiltrating" personal space,

"Being a client and a maker

are absolutely identical in every way.

The only fresh thing in the equation

is the object."

—G.P.

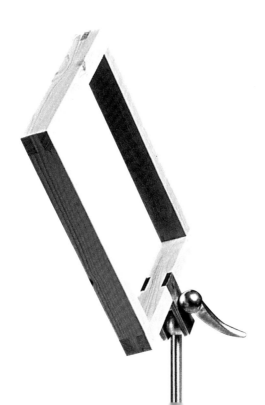

and indeed this work would not perform well as pure sculpture. In the house of a client, a table can lie just beneath notice, innocuously supporting everyday activity rather than continuously announcing the presence of an artist's ego.

In *Best General View*, that supplemental condition is turned to advantage, as the two tables metaphorically act as silent observation posts. The work brings into the open that which is usually tacit in the curious commodity structure of art. In any case where one person collects the art of another, both parties might justifiably lay claim to definitive ownership. As is suggested by Peteran's seemingly contradictory title, both artist and client occupy the "best" vantage point on the work, but at the same time, each is the subject of the other's surveying ("general") gaze. The work enacts this face-off of egos in terms of suspicion and vigilance, but also mutual respect. Peteran shows us that the artwork is only an intermediary in this process. The purchase of any artwork is, superficially, a matter of the object itself—the valued commodity, the work of skill or genius. This doubled table, though, does only one thing. It stands in the middle, and knowledge of one person by another is the real objective.

CAT. 11

Best General View

2002

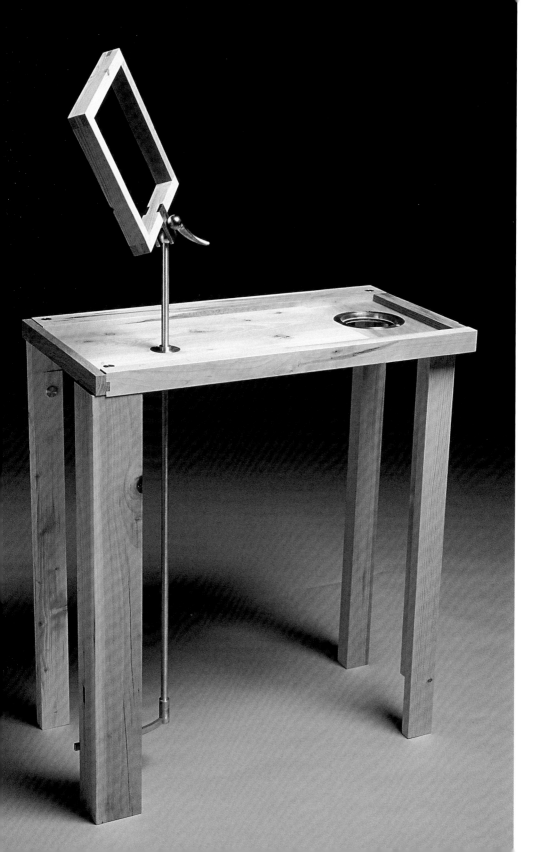

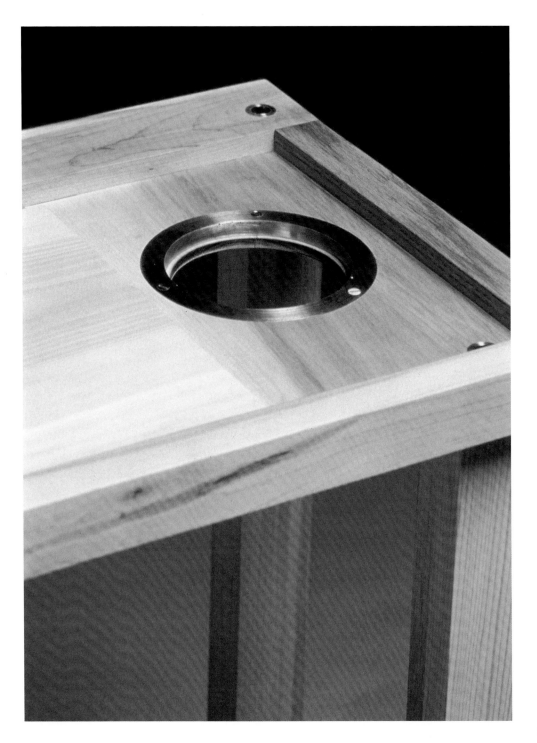

Best General View in William Anderson's studio.

Best General View (detail)

Best General View in Gord Peteran's home.

2002

Five Sounds, 2002

CAT. 12 Graphite on paper

Five framed drawings, 36 x 27 in. (91.4 x 68.6 cm) each

Wood Turning Center Collection, donated by the artist

I f one were looking to illustrate David Pye's famous distinction between the "workmanship of risk" and the "workmanship of certainty," one could do a lot worse than Peteran's lathe drawings entitled *Five Sounds*. Pye distinguished between techniques of making that involve unpredictability and are controlled through skill (such as cutting a straight line with a knife) and those that are regular, repeatable, and automatic (cutting a straight line with a paper cutter). In between these poles lie various compromises (such as cutting with a pair of scissors), which partly regulate the work while admitting of some fine control. Each drawing in *Five Sounds* exists at a precisely calibrated point on this continuum between risk and certainty.

Made at a residency hosted by the Wood Turning Center, the drawings are a response to the proposition that work be made using a particular tool (the lathe). For Peteran, this is entirely backward logic—he would normally no sooner specify a tool in advance than he would a certain type of wood, or even a specific final weight for the object. Yet one can imagine him working creatively in response to any of these arbitrary constraints. In the case of *Five Sounds*, the drawings are themselves the results of a play between gesture and constraint. They constitute an artistic response to the particular circumstances in which he found himself. Beyond this specific context, though, they offer a meditation on the aesthetic results of different ways of making. Peteran has here captured the relative nature of craft skill itself, which is never a known quantity, but always a relative and intangible phenomenon enacted through the triangular struggle of maker, tool, and work.

"These pencil lines trace the point of engagement between

the will of the material and the will of the maker

during the turning event.

Curiously, as I reflect back on these, I remember clearly

the sound each process produced.

I therefore have titled these drawings *Five Sounds*."

—G.P.

A Little Table, 2002

CAT. 13 Walnut

10 x 10 x 14 in. (25.4 x 25.4 x 35.6 cm)

single joint lies askew on a tabletop, "just approaching," as Peteran puts it, "a structure that might be a table." Neat ovolo moldings run down three edges, implying an outside, a set of three faces that are intended to be presentable or possibly, someday, functional. They remind one, mainly, of a table's top, front, and side. But there is no difference between these faces and those on the "interior" of this perfectly finished, beautifully made conundrum. The way to experience it, really, is to hold it in one's hands, turning it over and over. It is an ungainly little thing, lopsided, and cropped in places that feel at once arbitrary and inevitable. It is obvious that what's at stake in this object is the distinction between furniture and sculpture, so manipulating it in this way (a manipulation that is foreign to our experience both of tables and of sculptures) feels like a kind of transgression, a willful refusal to allow the object to land in either one camp or the other. As modest a work as it is, *A Little Table* is Peteran's most concise and resolute statement of a lack of commitment in these matters. From its toppled-over position, it implies that other artists who claim to have productively confused functional objects with sculpture must reexamine their arguments and, like Peteran, seriously consider what it would look like if they started from scratch.

"A little table—

not a lot."

—G.P.

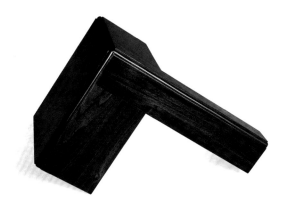

Mechanics of Memory, 2002

CAT. 14 Found and altered objects, found coatrack

Approx. 72 in. (182.9 cm) high.

Collection of William Anderson

owhere is Peteran's fascination with the found object expressed more clearly than in *Mechanics of Memory*. The assemblage has the random quality of detritus and in this regard participates in a worthy art historical lineage, through Robert Rauschenberg and ultimately back to the *Merzbau* of Kurt Schwitters. Any collection takes a position somewhere between the poles of intentional composition, on the one hand, and random accumulation, on the other. *Mechanics of Memory* seems inclined toward the latter. The casual disposal of objects in the work suggests that they are just visiting, as does the use of a coatrack, a furniture form that itself is symbolic of transience. And yet, as is suggested by the work's title, there is a certain nostalgic air, an emotional weight, to each of these things: a leather bag, from some forgotten trip; a fragmentary bentwood chair, the remnant of café discussions now over; and the antlers of a dead animal. Read against the more clinical works in Peteran's oeuvre (such as the part-by-part composition of found scraps that is *A Table Made of Wood* [cat. 8]), this emotionally charged gathering betrays the fact that, despite what the artist calls his "accidental aesthetic," he may just remain a romantic at heart.

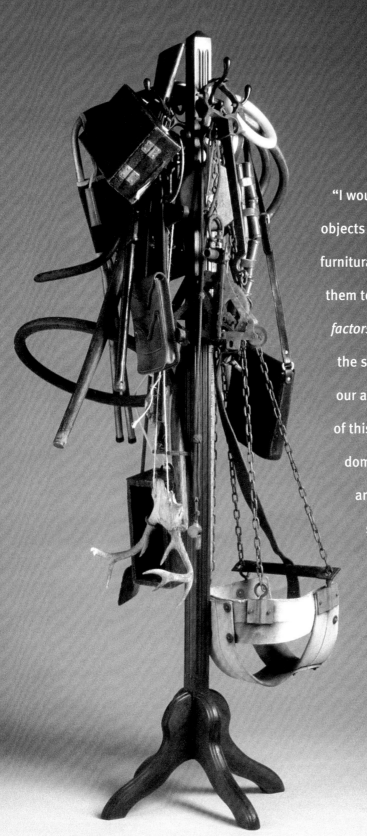

"I would certainly call the objects I make furniture or furnitural, because I expect them to talk about *all of the factors* related to causing the space between us and our architecture. Because of this close proximity the domestic objects we arrange within those spaces are charged with the symptoms of life."

—G.P.

Three Bronze Forms, 2002

CAT. 15 Walnut, felt, bronze

Approx. 36 x 24 x 18 in. (91.4 x 61 x 45.7 cm)

hether one finds *Three Bronze Forms* to be an exercise in frustration depends very much on one's expectations. Certainly a game of some sort seems to be in the offing: three machined bronze pieces sit heavily on the surface, ready to be handled. Putting them together yields the immensely satisfying click, almost a kind of suction, that only a perfect fit will deliver (like the parts of *100* [cat. 5], the pieces are machined to tolerances of less than a thousandth of an inch). But they don't come together to form a larger whole shape, nor do they imply any other rules of engagement. If this is a puzzle, it remains permanently unsolvable.

It is typical of Peteran's productive perversity when faced with an assignment that *Three Bronze Forms* was made for an exhibition on the theme of sustainability. Other artists took this as a cue to "reduce, reuse, recycle," the triad of environmentally conscious design, and so produced such things as sofas from bubble wrap and chairs from rolled newspaper. Peteran regarded these design solutions as "all bandaids to the fundamental problem." Certainly, in the context of a show of one-of-a-kind objects, the best that furniture can do is model possible ways forward. Peteran took it upon himself to do this by making a work that was *about* sustained engagement, rather than an instance of environmental sustainability.

The table in *Three Bronze Forms*, with its dark walnut and green baize, refers explicitly to historical game tables. And like a game table, it initially seems merely a backdrop for the main event to be played. Peteran has said: "That work uses a piece of furniture literally as a pedestal. The table that it's on, and in, is merely a frame." Yet he continues: "But at the same time, you can never underestimate the effectiveness of a fabulous frame. The frame's fifty percent of a painting, just to start a good argument." Indeed, as one manipulates the bronze forms atop the table, one is gradually made to question the degree to which the "game" is a matter of situating the forms in relation to one another. Because they refuse to cohere into a stable configuration, there is a

"I was searching here for the principles that allow objects to sustain.

To endure."

—G.P.

temptation to stop putting them together and instead begin arranging them into compositions on the tabletop. This brings into focus the edges of the baize surface, which suddenly seem the only certainties, the only ground rules—except that removing a piece of bronze entirely from the field of play would seem, somehow, "wrong." If the riddle is "what allows us to sustain our relation to our environment?" then furniture itself is Peteran's answer—conceived not as a product, but as a condition.

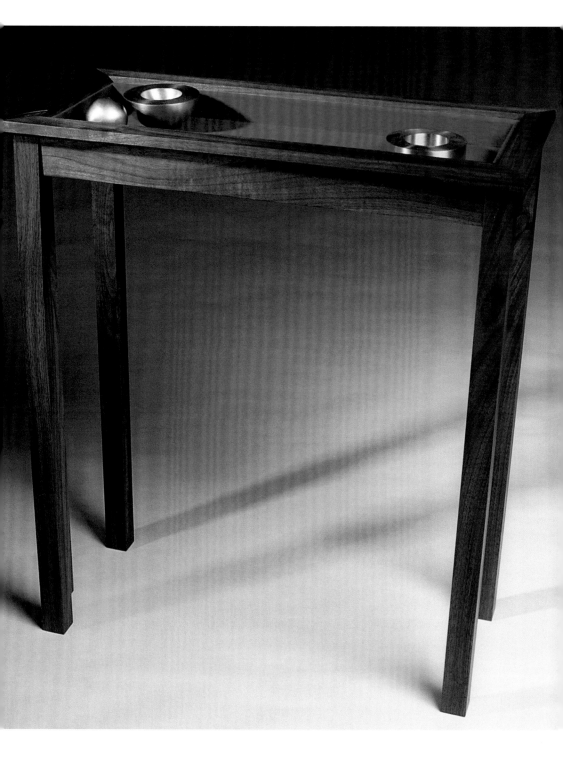

Workbench (Compass), 2002

CAT. 16 Beech workbench, compass

Dimensions not recorded

Anderson Ranch Arts Center

n one of his many residencies, Peteran visited the remote campus of Anderson Ranch Arts Center, located in Colorado. Legend has it that he spent nearly his entire time there lost. He claims that it was a confusing landscape. As Gail Fredell, a colleague there that summer, remembers it: "When you go down in altitude, you are going north. When he got here he became completely disoriented, and couldn't figure out which way was which. The whole time he was here, we were all asking 'where's Gord?' 'where's Gord?'"[3] Though he mainly made paintings while in the mountains, Peteran did find time for one conceptual gesture: he drilled a hole in the surface of Fredell's expensive new workbench and sunk a compass into it. It was a gesture of rare insolence. Fredell, for one, still hasn't quite forgiven him. "It was a big, beautiful workbench, never been used," she points out. Yet there was something more to the act than random vandalism. The crafts have a great tradition of the pastoral retreat, dating back to the idealistic days of the Arts and Crafts movement and continuing into the postwar period in dropout communes, isolated individual workshops, and (perhaps most prominently) summer workshops such as Anderson Ranch. At these locales, even a banker or lawyer can adopt a posture of noble disengagement, apart from the fray, and pursue a higher calling of an honest day's work. Peteran, unsurprisingly, seems to have regarded this idealistic setting with more than a little skepticism. The implanted compass declares, effectively, "You are here."

Interestingly, there is a long tradition of using the cardinal directions—north, south, east, and west—to assert the impossibility of pastoral retreat. In 1968, for example, the Minimalist sculptor Carl Andre also went to Colorado, making a pair of sculptures using rocks and logs he found there. Shortly after his return, he wrote: "I have a definite feeling that Aspen needed very little of my art. I think to a great extent my work was inappropriate there."[4] A few years later, however, in the safe confines of a New York gallery, he created a series of sculptures entitled *The Way North*, *The Way East*, and so on, through the points of the compass. In this case, the cumulative effect was to suggest that the "way" indicated by the work was "anywhere *but* here." Andre's

"I remember thinking this is invasive;

this is criminal.

This was her brand new workbench. It was brand new,

and she was so proud of it, so happy.

And here I did this."

—G.P.

Maypole, 2003

CAT. 17 Found and altered objects, fabricated brass

96 x 36 x 36 in. (243.8 x 91.4 x 91.4 cm)

Collection of William Anderson

hen Peteran was invited by the John Elder Gallery in New York to participate in a thematic show entitled *Naughty: Furniture Designed for Sex*, he at first rejected the idea—perhaps out of an impatience with the connotations of broad humor that such a theme implied. Peteran is scathing about the broad humor that is rife in the contemporary craft world. ("Some people 'tell jokes' with their work," he has written. "One needs to decide if this is a necessary contribution to the field.") But, upon further reflection, he changed his mind about the show: "that's exactly where I should be." No surprise there: sexuality is passed over decorously in most furniture, but it is a central point of enquiry for psychology. So the subject appealed to both his contrarian and analytical instincts.

Ultimately the object that Peteran contributed to the Elder Gallery was *Maypole*: a found wooden table with a system of brass additions, which are reminiscent of the symbiotic construction in his earlier work *Prosthetic* (cat. 10). Two latching harnesses, something like the safety seats on a child's swing set, hang from a central shaft; a missing foot has been replaced with a bit of brass; and curious handles (again related to an earlier work, this time the loops atop *Ark* [cat. 9]) are placed at the tabletop's corners. A third rope hangs, limp and frayed, from the central pole. The sum total is an object that ranks with Peteran's most disturbing. True, it could be a purpose-built device for sadomasochists, but it is difficult to imagine exactly how it would work— if the piece suggests "perversion," then it does so nonillustratively. *Maypole* is best viewed, then, outside its original, overtly thematic context. Peteran has said that the work would ideally be encountered entirely by chance, perhaps in an antique store in some quiet rural town. "Oh," its finder might say, "I don't think I want that in my house." While this imaginary narrative is unnecessary to the work (which performs its curious nonfunction perfectly well in a museum gallery), it nicely captures its aesthetic. In his typically roundabout way, perhaps Peteran did meet the brief of the exhibition. The work is not "naughty," goodness knows, and it is not precisely "designed for sex" either. But it is certainly about the collision of fear, pleasure, and intimacy. And as any honest person will tell you, that is what sex is all about.

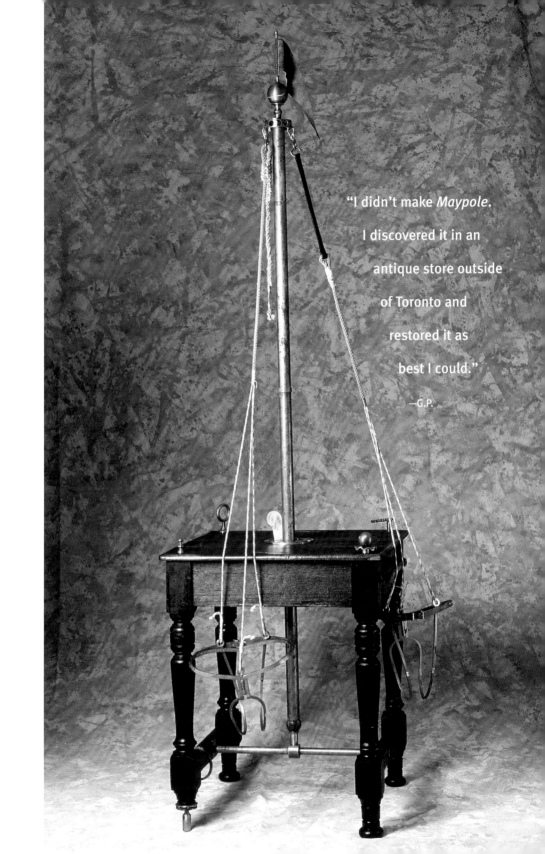

"I didn't make *Maypole*.
I discovered it in an
antique store outside
of Toronto and
restored it as
best I could."

—G.P.

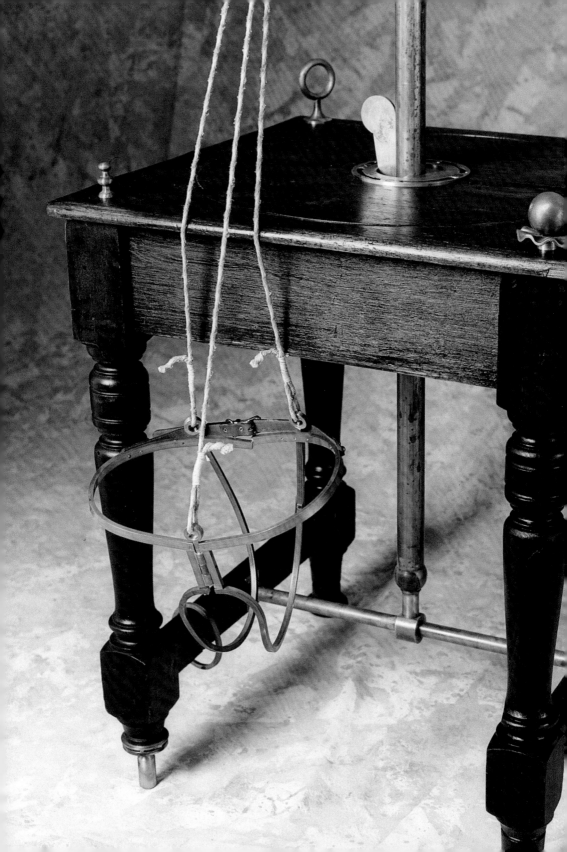

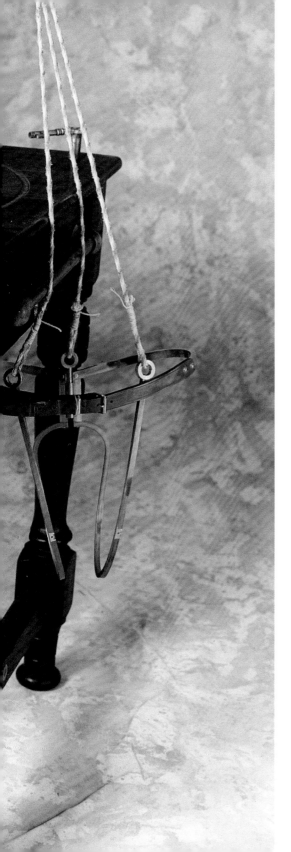

CAT. 17

Maypole (detail)

2003

An Early Table, 2004

CAT. 18 Twigs, string

36 x 40 x 17 in. (91.4 x 101.6 x 43.2 cm)

Collection of William Anderson

"Twig furniture" dates back at least as far as the pattern books of the mid-eighteenth century, when Thomas Chippendale included images of chairs and tables made of unshaped sticks alongside more conventionally styled designs. At the time, this "rustic" aesthetic was a nod in the direction of the pastoral rococo and hence inextricably linked to the faux naturalism common on country estates at the time, where landscapes were reshaped to look unspoiled and the inhabitants often dressed with a suspiciously studied informality. Ever since, from the cast-iron outdoor seating of the nineteenth century to today's "authentic" Adirondack chairs made from branches, twig furniture has embodied a false primitivism.

Peteran zeroes in on this essentially fictional genre of furniture in *An Early Table*. In compositional terms, the piece is clearly related to *A Table Made of Wood* (cat. 8), and if anything it is more dramatically provisional in its structure. So much is clear from the placement of the ball of string atop the table, which implicitly invites us to unwind the object and return it to its "natural" state. This satirical note relates directly to the title, which swipes at the ideal of rustic simplicity that twig-furniture makers hold dear, but at the same time suggests a quasifictional primordial moment, in which furniture as we know it did not yet exist. This parallel universe of making is also manifested in *An Early Knife* (fig. 9), a simple conjunction of three found tool parts. Both pieces enlarge upon Peteran's customary game of the found object—here he plays at the role of the archaeologist, as if he had discovered these relics and were presenting them for scholarly contemplation, or perhaps at that of a prehistoric artisan himself, grasping toward a resolved form but not yet reaching it. In the latter scenario, the effect is to produce a sort of yearning wonderment at things that we take for granted. It is as if tables and knives do not exist yet, and we are invited to participate in the difficult process of imagining them for the first time. Once again Peteran stands, metaphorically, at an extremity of furniture history. This time, however, he notionally positions himself at furniture's beginning rather than its end: its delivery, rather than its funeral. Perhaps unsurprisingly, these two moments turn out to look much the same.

"I look around,

and all the evidence points to:

you're a furniture maker.

How did I get here?

It's a conundrum."

—G.P.

TWO, 2006

CAT. 19 Walnut, brass

14 3/4 x 14 3/4 x 67 1/2 in. (37.5 x 37.5 x 171.5 cm);

brass brace: 20 x 16 x 9 in. (50.8 x 40.6 x 22.9 cm)

A s Peteran has become an ever more sophisticated conceptualist, his works have, on occasion, veered closer to the visual appearance of Conceptual art itself. This might be a coincidence. The work *Two* was made for an exhibition in which makers were asked to contribute a pair of chairs. As is his usual practice, Peteran burrowed into the theme itself rather than choosing to render it in an individuated fashion. His contribution consisted of a single supine form, composed of two identical chairs rotated ninety degrees with respect to each other. The legs are continuous pieces of wood. As Peteran has put it, "a saw cut of 1/64 inch thickness would make two chairs." *Two* is intriguing conceptually because it exists simultaneously as the raw material for two finished objects and also as a finished object in its own right. But to return to the matter of resemblances: anyone familiar with postwar art will recognize in *Two* a distinct formal similarity to Conceptual art, specifically Sol LeWitt's white sculptures of the late 1960s and 1970s (fig. 21). These were essays in the notion that art could be a feat of ideation, and nothing more. Just as LeWitt's later wall drawings were executed by a team of assistants, his steel cages were fabricated by workers according to a precise set of instructions, making it an open question as to whether the instructions or the object actually constituted the work. Formally the sculptures have the quality of diagrams, often running through sets of mathematical permutations. It is as if LeWitt was trying to make pure derivatives of unspoken abstract principles, yet it was of course the "as if" that constituted the interest of his undertaking. What one encountered in the gallery was not an immaterial principle by any means, but a big, heavy, gleaming metal structure. The seemingly incidental aspects of its appearance, because they seemed hard won, took on a gravity of their own. LeWitt had shown that the sensory rewards of an object are heightened, rather than eliminated, by the pressure of precise thinking. He caught the great problem of his day—the relation between object and idea—flat-footed, showing that this duality was most productive when expressed in the starkest possible terms.

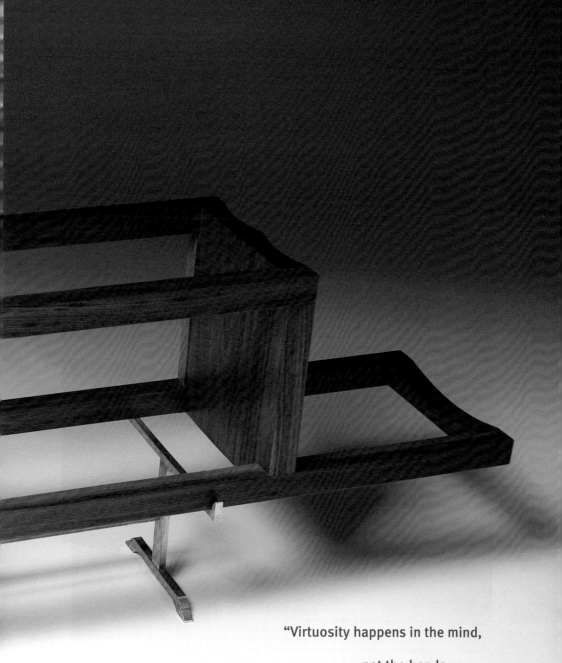

"Virtuosity happens in the mind,

not the hands.

I think."

—G.P.

Study Station, 2006

CAT. 20 Found wood and metal, leather, thread, brass, glass, hair

37 x 21 x 27 in. (94 x 53.3 x 68.9 cm)

I t was inevitable that when faced with the prospect of a retrospective exhibition of his work, Peteran would make an object as a way of dealing with the experience. He does this all the time when encountering a curatorial premise. In the past his reactive instincts have led him to produce such works as *Ark* (for a thematic show about comfort), *Maypole* (ditto, sex), *Three Bronze Forms* (sustainability), and *Two (pairs)* (cats. 9, 17, 15, and 19, respectively). The notable difference of course is that in this case the theme of the exhibition is none other than Gord Peteran—his history, his intentions, and his objects.

Study Station accomplishes its retrospective function partly by quoting past works. The white leather that is stretched and stitched over the object's underlying structure inevitably recalls *Untitled So Far* (cat. 6); the color shift from red to white suggests that some form of purification or redemption has occurred. Equally obvious are the references to *Prosthetic* (cat. 10), in the form of a brass implement that sits atop the object's integral writing surface and a metal prop that serves as a seemingly provisional front leg. Other borrowings from Peteran's past oeuvre are more subliminal: the inclusion of what seems to be a tree branch for the other front leg may be a tip of the cap to *An Early Table* (cat. 18), while the thrown-together, piecemeal assembly, bursting out of its white skin, suggests continuity with the pressurized composition of *A Table Made of Wood* (cat. 8). More important than any of these specific allusions, though, is the sense that *Study Station* is itself an object that suggests a long growth process. It is, in Peteran's words, "an object that seems to have cobbled together itself, carefully, from within."

The overall form, that of a school chair, also brings to mind a long process of formation—countless uncomfortable afternoons spent learning, under intense scrutiny by the authorities. Peteran's suggestion that the work be exhibited in his retrospective "under a strong spotlight, hung straight overhead" dramatizes this sense that an examination, or perhaps even an interrogation of sorts, is being conducted.

"Furniture is sustenance

for only one."

—G.P.

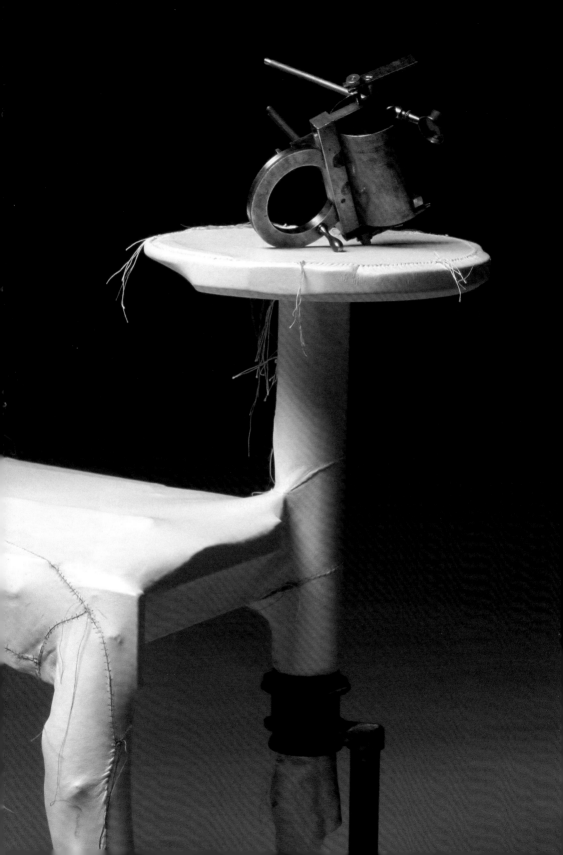

Gord Peteran studying *Study Station*.

CAT. 20

Study Station (detail)

2006

Fault Line, 2003

Framed WilsonArt (graphic laminate)

48 x 144 in. (121.9 x 365.8 cm)

Collection of Diane and Marc Grainer

"Furniture is our first sculptural encounter, after the body of the mother and slightly before the interior spatial volumes of architecture. I believe our relationship with the furnitural form remains suspended between those two early experiences."

—G.P.

NOTES

Dimensions are given in the following order: height, width, depth. Works for which no credit line is given are from the collection of the artist. All quotations from the artist are from conversations and correspondence with the author that took place between around 2000 and 2006.

1. Betty Ann Jordan, "Generating an Object from Within," *Ontario Craft* 26 (Summer 2001): 6.

2. John McAlister, letter to the editor, *Woodwork*, no. 84 (December 2003): 8; Doug Alderman, letter to the editor, *Woodwork*, no. 86 (April 2004): 6; Greg Heppeard, letter to the editor, *Woodwork*, no. 85 (February 2004): 6; John McAlevey, letter to the editor, *Woodwork*, no. 85 (February 2004): 6. For the photograph of *A Table Made of Wood* that prompted the discussion, see *Woodwork*, no. 83 (October 2003): 47.

3. Gail Fredell, conversation with the author, July 2005.

4. Carl Andre, untitled 1968 interview with Willoughby Sharp, *Avalanche* 1 (Fall 1970): 18.

FIGURES

FIG. 11
Clock, 1992
Wood, bronze, steel, and other materials
84 x 48 x 24 in. (213.3 x 121.9 x 61 cm)
Metro City Hall, Toronto

FIG. 12 AND 13
Chestnut Park Doors, 1991
Sand-cast bronze, wood
105 x 67 x 17 in. (266.7 x 170.2 x 43.2 cm)
The Amesbury Chalmers Collection

FIG. 14
Up, 2005
Carpenter's glue
2 x 4 in. diam. (5.1 x 10.2 cm diam.)
Collection of Tim and Sheryl Kochman

FIG. 15
Two Bracelets, 2002
Pencil shavings
Dimensions variable

FIG. 16
Professor Garrison's Lesson, 2002
Wooden bowl fragments, brass, turned wood handle
16 x 16 in. (41 x 41 cm)
Wood Turning Center Collection

FIG. 17
Chest in a Bowl, 2002
Willow
20 x 22 x 22 in. (50.8 x 55.9 x 55.9 cm)

FIG. 18
Fernando and Humberto Campana (Brazilian, b. 1961 and 1953)
Favela Chair, 1991
Manufactured by Edra since 2003
Brazilian pine
29 x 26 x 24 in. (73.7 x 66 x 61 cm)
Courtesy of Edra, Italy

FIG. 19
A Table Made of Wood, 2005
Various woods, screws
34 x 37 x 17 in. (86.4 x 94 x 43.2 cm)

FIG. 20
Suspended Table, 2005
Brass and fiberglass
38 x 38 1/4 x 22 in. (96.5 x 97.2 x 55.9 cm)

FIG. 21
Sol LeWitt (American, b. 1928)
Incomplete Open Cube 9-12, 1974
Painted aluminum
41 3/8 in. (105.1 cm) square
Milwaukee Art Museum, Purchase, National Endowment for the Arts Matching Funds, M1982.35. © 2006 Sol LeWitt / Artists Rights Society (ARS), New York

THE VIEW FROM MY WINDOW
IN THE I.D.S. CENTER
MINNEAPOLIS 2001
PETE LAU

Gord Peteran's Top Ten Shop Rules

A Hypothetical Response

GORD PETERAN

Gord Peteran's Top Ten Shop Rules

"Always error on the side of ridiculous"

"If something's not worth doing, it's worth not doing well"

"If something's worth not doing well, it might be worth doing perfectly"

"Charge a lot of money"

"The source of creativity is a limited attention span"

"Procrastination is good, because panic, confusion, sweat, danger, lying to clients, not eating, not sleeping and riding on credit, builds character"

"Learn to shut up"

"Burn all mistakes thoroughly"

"Medically speaking, your head is connected to your ass"

"Plan on going to hell"

"Never hire someone capable of emotions"

"What people say is quite often a clue to what they're thinking"

—G.P.

A Hypothetical Response to a Hypothetical Question Someone Like Glenn Adamson Might Ask

ll great sculpture is furniture. The premise of a sculpted artwork is a movement toward the body, slowly slithering through our domestic landscape into our private spaces, inhabiting that privileged position next to our flesh and every thought. A clear and present danger quite different than the way we internalize a painting. No safety of flatness or coddling containment of frame and wall.

A thing does not have to look like furniture to be furniture. Most constructed things unwittingly toy with the situation of furniture. The bodular projection and boney mimicking of what we imagine to exist structurally inside: the propped-up-ness of the human experience, the supportive reflective role we designate to the things we place on the outside of the body, the conjunctive nature of thinking, the drama, the dirtiness, the pre-meditative assembly, and the ever-pending dismemberment of all things. I guess, perhaps, that all objects have this, but furniture flaunts it. In a world of deception, furniture is the most deceptive thing of all. Everyone sees it but it sneaks in under the radar.

I do not trust a chair as far as I can throw it, and often have—only to feel a deep remorse and have to deal with it . . . and the chair. So I attempt to repair it, as I do many things. I suspect that all making is repair, re-"pairing up" the two things that get misaligned in our present and past definitions of "the real"—perhaps the source of all desire.

I've thought a lot about the nature of want, about desire, about addiction and specifically about our addiction to objects. Even our present minimalist sensibility within an overwhelming production of stuff and our insatiable appetite for sustaining the "new" are symptomatic of this struggle. These dualities reassure me that something essential, something primal, is still alive and well. The "ideal object" remains suspended somewhere in between, hovering within the marks of the artist, the marks of the body and the marks of the eye.

I can't imagine staying indefinitely within the realm of the furnitural object. But I'm slow to develop and still quite shy about the body. At present though, the territory it occupies provides a perfect host for my sometimes-predatory investigations, a cradle for my laboratory, a gentle frame for the often-dangerous subject matters of art.

Perhaps someday I'll get up out of my chair and move on.
Or not.

GORD PETERAN | 2006

5 ◄ 6. ◄

7 ILFORD XP1400 A 012

7 ◄ 8 ◄

ILFORD XP1400 0127

Checklist of the Exhibition

Chest on Chest, 1984
Red oak, ebonized cherry
Two parts: 40 x 32 x 19 in. (101.6 x 81.3
x 48.3 cm), 10 x 8 x 3 3/4 in. (25.4 x 20.3
x 9.5 cm)
Lent by David G. Burry

Boardroom Door, 1990
Red oak, brass, oil paint, etc.
108 x 70 7/8 x 8 in. (274 x 180 x 20.3 cm)
Lent by the Ontario Crafts Council

Chestnut Park Doors, 1991
Sand-cast bronze, wood
105 x 67 x 17 in. (266.7 x 170.2 x 43.2 cm)
Lent by The Amesbury Chalmers
Collection

Musical Box (Glenn Gould Prize), 1996
Red oak, brown oak, steel, ebony,
brass, aluminum, plastic, leather,
rock, copper
5 7/8 x 29 1/2 x 19 5/8 in. (15 x 75
x 50 cm)
Lent by the Glenn Gould Foundation
and Glenn Gould Studio

100, 1996
Machined bronze, ebony, custom-built
oak and leather case
Table: 27 x 27 x 27 in. (68.6 x 68.6
x 68.6 cm)
Case: 5 x 27 x 18 in. (12.7 x 68.6 x 45.7 cm)
Lent by Sylvia and Garry Knox Bennett
(Two identical versions appear in the
exhibition, one assembled and one
disassembled in its case)

Untitled So Far, 1996
Found wood turning, red leather,
linen thread
20 x 7 x 7 in. (50.8 x 17.8 x 17.8 cm)
Lent by the Wood Turning Center
Collection, donated by Albert and
Tina LeCoff

Beam, 1999
Oak, brass
26 1/2 x 15 x 111 in. (67.3 x 38.1 x 282 cm)
Lent by William Anderson

A Table Made of Wood, 1999
Various woods
31 x 37 x 14 in. (78.7 x 94 x 35.6 cm)

Ark, 2001
Stained oak, metal, velvet, glass,
electrical cord
72 x 42 x 25 in. (182.9 x 106.7 x 63.5 cm)

Best General View #1, 2001
Found wood, brass
42 x 36 x 15 in. (106.7 x 91.4 x 38.1 cm)

Best General View #2, 2002
Found wood, brass
42 x 36 x 15 in. (106.7 x 91.4 x 38.1 cm)
Lent by William Anderson

Prosthetic, 2001
Found wooden chair, brass
36 x 17 x 17 in. (91.4 x 43.2 x 43.2 cm)
Lent by Douglas Nielsen

Five Sounds, 2002
Graphite on paper
Five framed drawings, 36 x 27 in.
(91.4 x 68.6 cm) each
Lent by the Wood Turning Center
Collection, donated by the artist

A Little Table, 2002
Walnut
10 x 10 x 14 in. (25.4 x 25.4 x 35.6 cm)

Three Bronze Forms, 2002
Walnut, felt, bronze
Approx. 36 x 24 x 18 in. (91.4 x 61
x 45.7 cm)

Two Bracelets, 2002
Pencil shavings
Dimensions variable

Fault Line, 2003
Framed WilsonArt (graphic laminate)
48 x 144 in. (121.9 x 365.8 cm)
Lent by Diane and Marc Grainer

Maypole, 2003
Found and altered objects,
fabricated brass
96 x 36 x 36 in. (243.8 x 91.4 x 91.4 cm)
Lent by William Anderson

An Early Table, 2004
Twigs, string
36 x 40 x 17 in. (91.4 x 101.6 x 43.2 cm)
Lent by William Anderson

An Early Knife, 2004
Found steel handle, found steel blade
Approx. 18 in. (45.7 cm) long

Electric Chair, 2004
Tubular steel and lightbulb
Approx. 45 x 30 x 30 in. (114.3 x 76.2
x 76.2 cm)
Lent by David Dorenbaum

Up, 2005
Carpenter's glue
2 x 4 diam. in. (5.1 x 10.2 diam. cm)
Lent by Tim and Sheryl Kochman

Study Station, 2006
Found wood and metal, leather, thread,
brass, glass, hair
37 x 21 x 27 in. (94 x 53.3 x 68.9 cm)

Two, 2006
Walnut, brass
14 3/4 x 14 3/4 x 67 1/2 in. (37.5 x 37.5
x 171.5 cm); brass brace: 20 x 16 x 9 in.
(50.8 x 40.6 x 22.9 cm)

Photography Credits

Colophon

This book was designed by Dan Saal, in collaboration with Gord Peteran, and edited by Karen Jacobson.

The typesetting and page design were done using QuarkXpress on a Macintosh G4 computer. The text is set in Meta, a typeface designed by Erik Spiekermann in 1989. The drop caps are set in Castellar, an all-capital display typeface designed by John Peters in 1957.

This catalogue was offset-printed in a first edition of 2,500 copies by The Fox Company, Inc. Lithographers, Milwaukee, Wisconsin.

The cover was embossed by L.A. Foil, Milwaukee, Wisconsin.

The essay sections are printed on Synergy Natural Felt from SMART Papers.

The "Works" section and the image on the cover are printed on Hanno'Art Silk from Sappi.

The flysheets are printed on Eames Architecture Text–Eames Natural White from Neenah Paper. This paper, developed in conjunction with the Eames Office, takes its cues from the legacy and ideas of Charles and Ray Eames.

The body of the catalogue was Smyth sewn and bound by P.S. Finishing, Milwaukee, Wisconsin.

Cover: *Fault Line* (2003; detail of cat. 21)

Published by the Milwaukee Art Museum, 700 North Art Museum Drive, Milwaukee, WI 53202, 414-224-3200, www.mam.org and the Chipstone Foundation, 7820 North Club Circle, Milwaukee, WI 53217, www.chipstone.org

Distributed by The University of Wisconsin Press

First Edition

Library of Congress Cataloging-in-Publication Data

Adamson, Glenn.
 Gord Peteran : furniture meets its maker / Glenn Adamson ; with contributions by Gary Michael Dault, David Dorenbaum, Gord Peteran.
 p. cm.
 Issued in connection with an exhibition held Oct. 5, 2006–Jan. 7, 2007, at the Milwaukee Art Museum, and at other institutions at later dates.
 Includes bibliographical references.
 ISBN-13: 978-0-944110-84-3
 ISBN-10: 0-944110-84-3
 1. Peteran, Gord, 1956---Exhibitions. 2. Furniture--Canada--History--20th century--Exhibitions. 3. Furniture--Canada--History--21st century--Exhibitions. I. Peteran, Gord, 1956– II. Milwaukee Art Museum. III. Title.
NK2443.P48A4 2006
749.092--dc22
 2006022554